Schleswig-Holstein

Streifzug von Küste zu Küste
Journey from coast to coast

Oliver Franke · Judith Leysner

Schleswig-Holstein

Streifzug von Küste zu Küste
Journey from coast to coast

WACHHOLTZ
MURMANN PUBLISHERS

Fakten: Schleswig-Holstein

Lage	Nördlichstes Bundesland
Fläche	15.764 km²
Einwohner	2.820.713
Hauptstadt	Kiel (241.000 Einwohner)
Binnenseen	ca. 300
Inseln	7
Küstenlinie	1.105 km
Deichlänge	430 km
Längster Fluss	Eider (180 km)
Höchster Berg	Bungsberg (168 m hoch)
Literaturnobelpreisträger	3

Facts: Schleswig-Holstein

Location	Northernmost federal state
Size	15,764 km²
Inhabitants	2,820,713
Capital City	Kiel (241,000 inhabitants)
Lakes	ca. 300
Islands	7
Coastline	1,105 km
Length of dyke	430 km
Longest river	Eider (180 km)
Highest mountain	Bungsberg (168 m)
Nobel Prize winners in Literature	3

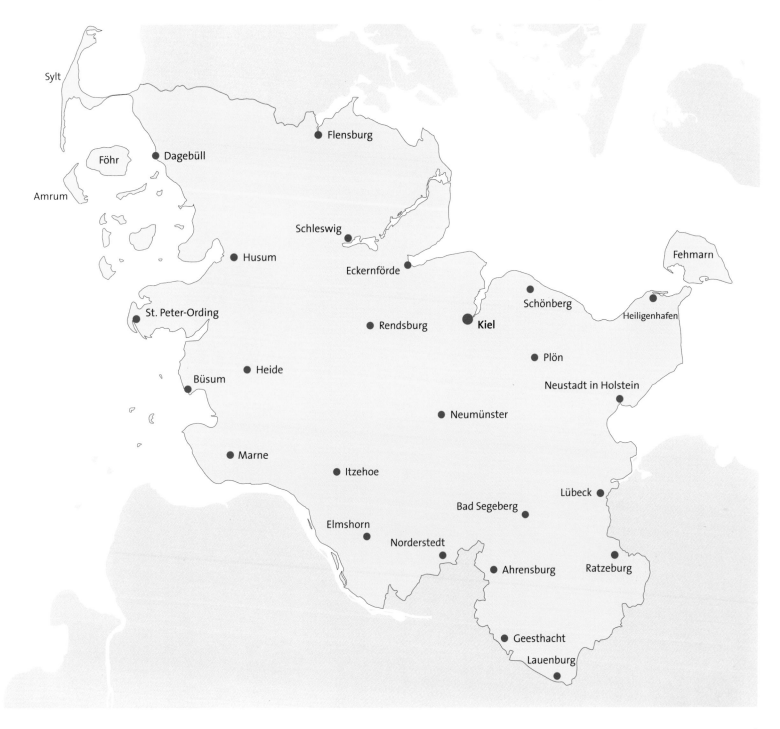

Sylt

Föhr

Amrum

Flensburg

Dagebüll

Schleswig

Husum

Eckernförde

Fehmarn

St. Peter-Ording

Schönberg

Heiligenhafen

Rendsburg

Kiel

Plön

Heide

Neustadt in Holstein

Büsum

Neumünster

Marne

Itzehoe

Lübeck

Bad Segeberg

Elmshorn

Norderstedt

Ahrensburg

Ratzeburg

Geesthacht

Lauenburg

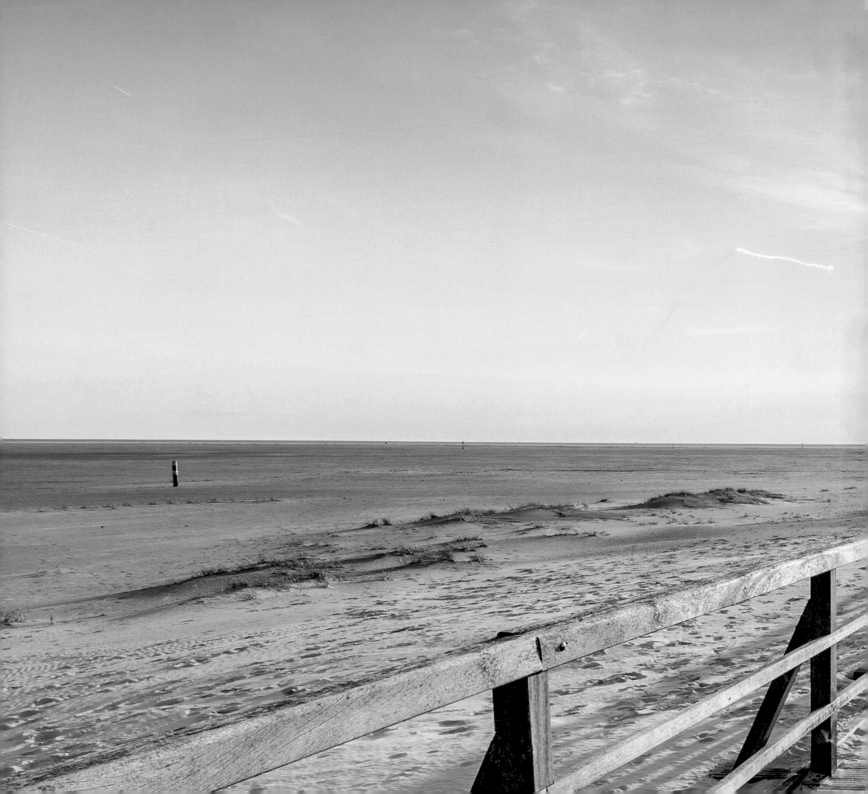

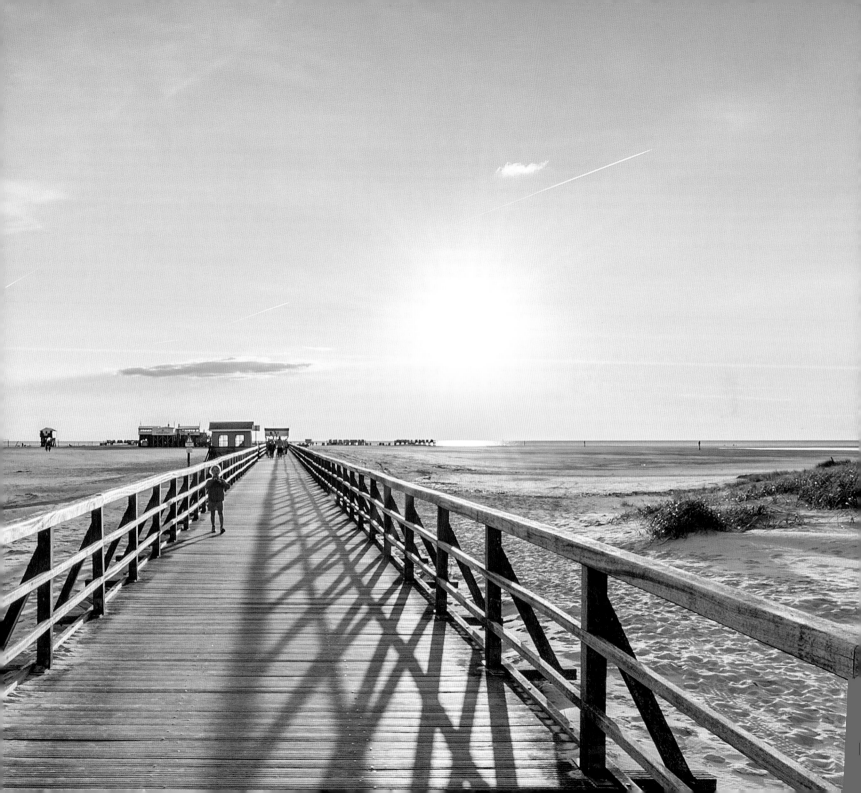

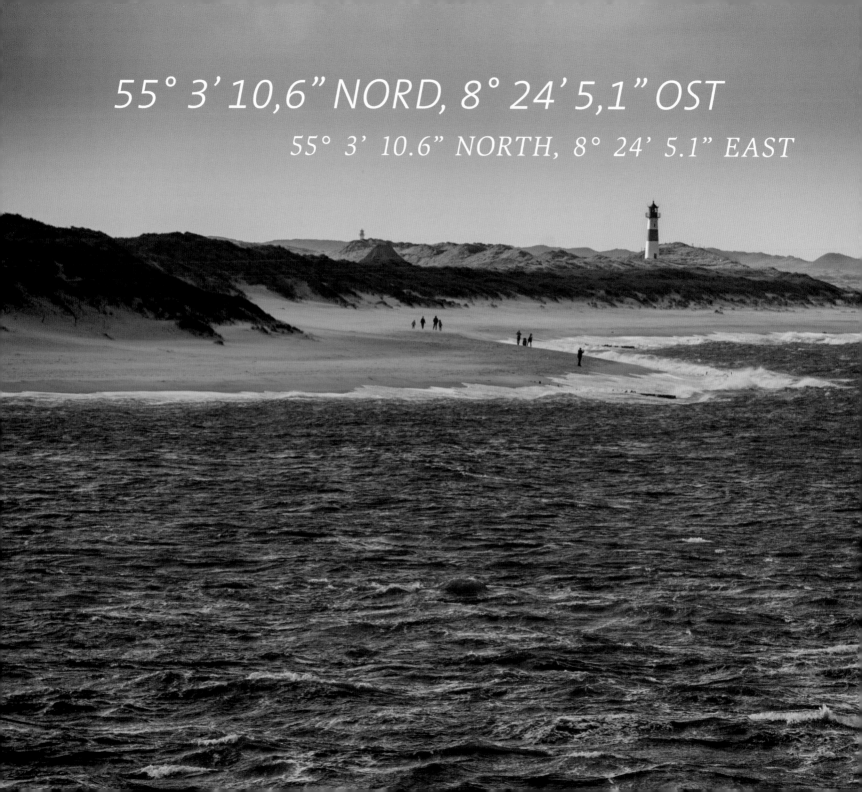

55° 3' 10,6" NORD, 8° 24' 5,1" OST

55° 3' 10.6" NORTH, 8° 24' 5.1" EAST

Am nördlichsten Zipfel Deutschlands beginnt unser Streifzug durch Schleswig-Holstein mit der »Königin der Nordsee«: SYLT – die Insel der Reichen und Schönen –, mondän und schick, ist vor allem wunderschön. Einsame Strände, weite Dünenlandschaften und das stete Rauschen der Nordseewellen machen den charakteristisch geformten Ellenbogen zum Paradies für Ruhe- und Erholungsuchende.

Our journey through Schleswig-Holstein begins at the northernmost point of Germany, the »Queen of the North Sea«: SYLT. It is the island of the rich and beautiful, sophisticated and elegant, but above all, gorgeous. Lonely beaches, wide dunescapes, and the constant noise of the North Sea waves make this characteristically formed elbow a paradise for those who seek rest and relaxation.

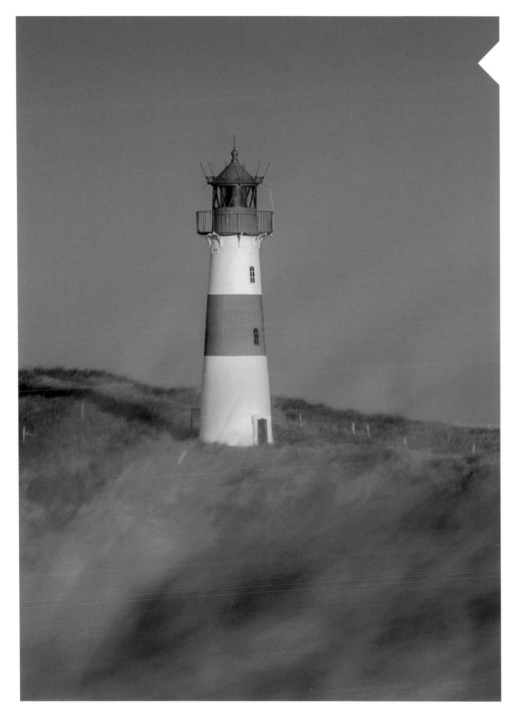

Die Zwillingstürme LIST-OST und LIST-WEST am SYLTER ELLENBOGEN trumpfen gleich mit zwei Superlativen auf: Sie sind nicht nur die nördlichsten Gebäude Deutschlands, sondern auch die ältesten gusseisernen Leuchttürme. Baugleich aus weißem Stahl und roter Kappe, trägt das Leuchtfeuer List-Ost zur Unterscheidung aus der Ferne ein rotes Band um den Bauch.

The twin towers LIST-OST and LIST-WEST near the SYLTER ELLENBOGEN boast two superlatives: They are the northernmost buildings in Germany and the oldest cast-iron lighthouses. Identical in construction and made of white steel and a red cap, the lighthouse at List-Ost can be distinguished from a distance by its red belt.

Fakten: Sylt

Größe	99 km²
Leuchttürme	5
Strandkörbe	ca. 12.000
Sandvorspülung 2015	1,75 Mio. m³ Sand
Kosten 2015	ca. 9 Mio. Euro

Facts: Sylt

Size	*99 km²*
Lighthouses	*5*
Wicker beach chairs	*approx. 12,000*
Beach replenishment 2015	*1.75 Mio. m³ sand*
Costs 2015	*approx. 9 Mio. Euro*

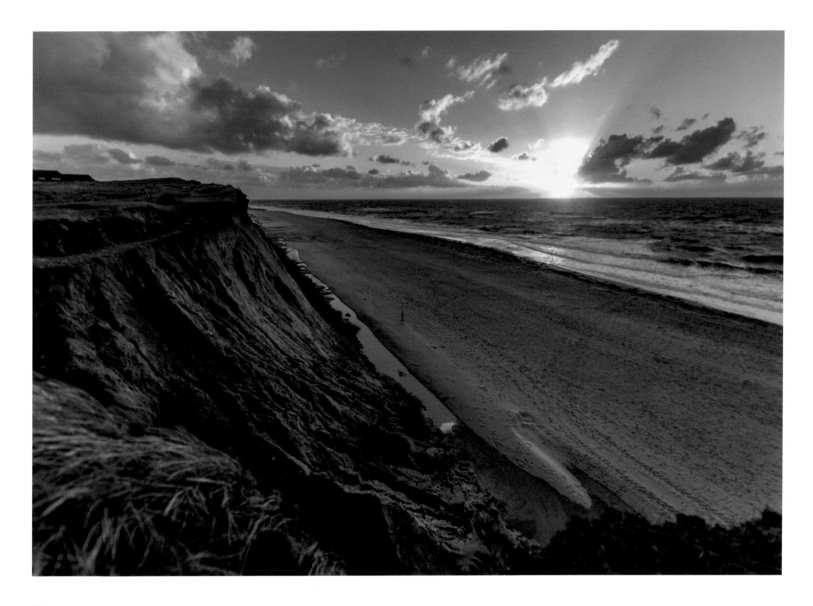

Das rund 30 Meter hohe ROTE KLIFF zwischen Kampen und Wenningstedt an der Westseite der INSEL SYLT ist zweifelsohne eine der faszinierendsten Steilküsten der Nordsee. Aufgrund ihrer auffälligen Färbung diente sie Seefahrern jahrhundertelang als untrügliches Erkennungsmerkmal. Seit 1979 steht das gefährdete Kliff unter Naturschutz – durch Sturmfluten und Erosion beträgt der Landverlust jährlich ein bis vier Meter.

The 30-meter-high ROTE KLIFF between Kampen and Wenningstedt, on the west side of the ISLAND OF SYLT, must be one of the most fascinating bluffs on the North Sea. For centuries, the characteristic colour offered a uniquely recognisable landmark to seafarers. The endangered bluff has been a protected area since 1979 – however, every year one to four metres of land are lost due to erosion and storm tides.

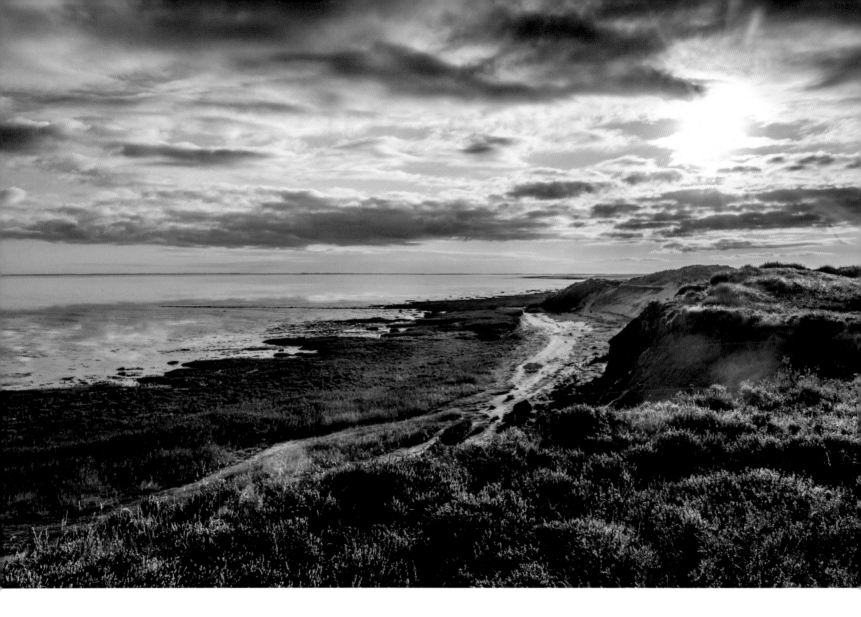

Fast wären Teile des MORSUM-KLIFFS Anfang der 1920er Jahre als Baumaterial für den Hindenburgdamm abgetragen worden. Drei Umweltaktivisten schafften es, dies zu verhindern, und das geologisch herausragende Kliff wurde 1923 als eines der ersten Gebiete in Schleswig-Holstein unter Naturschutz gestellt. Bis zu 10 Millionen Jahre alte, unterschiedlich gefärbte Erd-schichten sind nicht über-, sondern nebeneinander zu finden.

Parts of MORSUM KLIFF were almost removed in 1920 for use as building material for the Hindenburg Dam. Three environmentalists managed to prevent this fate and the cliff was put under protection in 1923, as one of the first natural preservation areas in Schleswig-Holstein. Earth layers in different colours, up to 10 million years old, are found here.

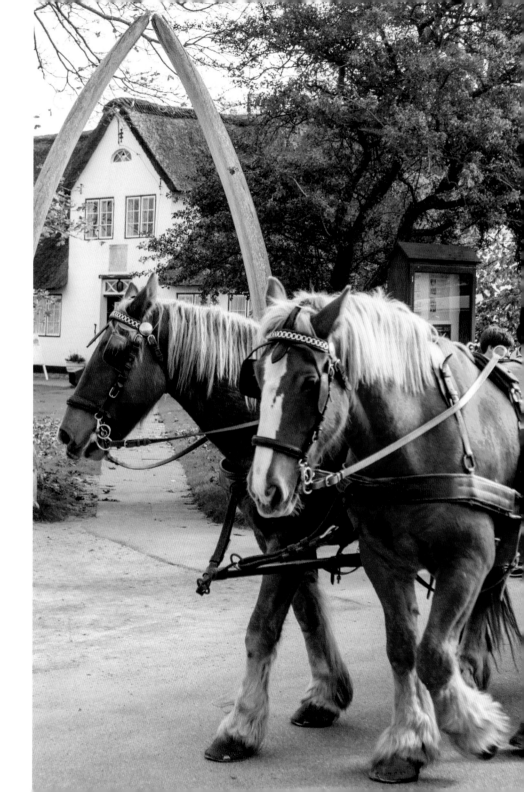

K EITUM, an der geruhsamen Wattseite
Sylts gelegen, ist mit seinen schmucken
Kapitänshäusern das schönste Dorf der Insel.
Von Seefahrern und Walfängern, friesischer
Kultur und Sylter Persönlichkeiten erzählt das
Sylter Heimatmuseum kurzweilige Geschichten.
Der riesige Unterkieferknochen eines 1995
gestrandeten Finnwals ziert seinen Eingang.

*KEITUM is the most gorgeous village on the
island, located on the tranquil side of Sylt's
Wadden Sea. It displays beautiful captain's
houses, and the museum of local history
tells charming tales of seafarers and whalers,
Frisian culture and Sylt's characters. The
massive jawbone of a 1995 beached fin
whale marks the entrance to the museum.*

EINBLICKE –
AUSBLICKE

INSIGHTS –
OUTLOOKS

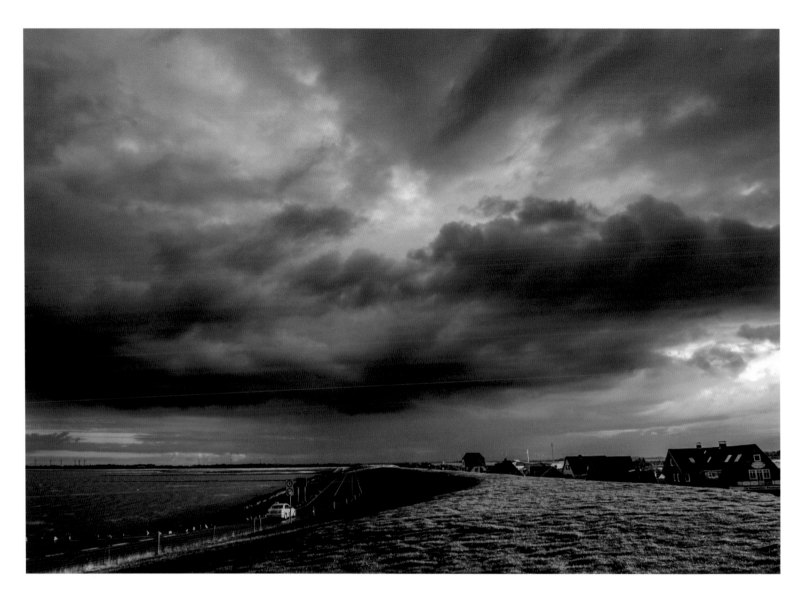

DAGEBÜLL gilt als »Fenster zur Nordsee«. Von hier starten die Fähren und Ausflugsschiffe zu den Nordfriesischen Inseln; zu den Halligen Langeneß und Oland geht es bei Ebbe mit einer Lore mitten durch das Wattenmeer. Dagebüll befand sich einst selbst auf einer Hallig – durch Eindeichungen wurde das kleine Hafenstädtchen im 18. Jahrhundert landfest.

DAGEBÜLL *is called the »window to the North Sea.« This is where the ferries and excursion boats leave for the Northern Frisian Islands. During low tide, a trolley across the Wadden Sea will bring you to the holms of Langeneß and Oland. Dagebüll was once a holm itself, but dyking during the 18th century enclosed the small harbour town by land.*

14

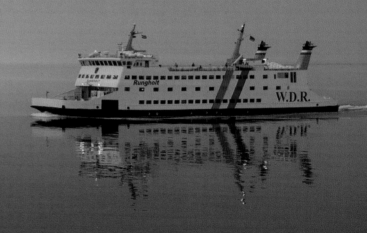

FACETTEN DER NORDSEE

FACES OF THE NORTH SEA

Mit der Fährüberfahrt vom Festland zu den Inseln Föhr und Amrum, an Seehundbänken und Halligen vorbei, beginnt das Urlaubserlebnis »Nordsee«. Je nach Wind, Wetter und Gezeiten überrascht das Meer mit seinen vielseitigen Facetten. Mal geht es ruhig und beschaulich zu – mitunter präsentiert sich die Nordsee auch von ihrer launischen Seite und zeigt, welche Kraft in ihr steckt.

The ferry ride from the main land to the islands Föhr and Amrum, passing seal banks and holms, brings on a North Sea holiday feeling. The ocean surprises us with its multiple facets of wind, changing weather, and tides. Some days calm and relaxed, on other days the North Sea shows its moody side and expresses itself in full f

Hoch zu Ross oder barfuß durch den Sand: Der NIEBLUMER STRAND auf FÖHR lädt zu abwechslungsreichen Entdeckungen ein. Fast unwirklich erscheint die Silhouette der Hallig Langeneß mit ihren kleinen Warften am Horizont. Die insgesamt zehn nordfriesischen Halligen – winzige, nicht eingedeichte Eilande inmitten des Wattenmeeres – sind weltweit einzigartig.

NIEBLUMER STRAND on the island of FÖHR invites you to make discoveries on horseback or barefoot. It's almost surreal to view the silhouette of the holm Langeneß' dwelling mound on the horizon. The ten North Frisian holms, tiny free-standing islands in the middle of the Wadden Sea, are unique in the world.

Fakten: Nordfriesische Halligen

Anzahl 19. Jahrhundert	über 100
Anzahl heute	10
Davon ständig bewohnt	7
Größte Hallig	Langeneß, 9,56 km²
»Land unter« pro Jahr	ca. 30-mal

Facts: North Frisian holms

Count 19th century	more than 100
Count today	10
Inhabited continuously	7
Biggest holm	Langeneß, 9.56 km²
Floods per year	approx. 30

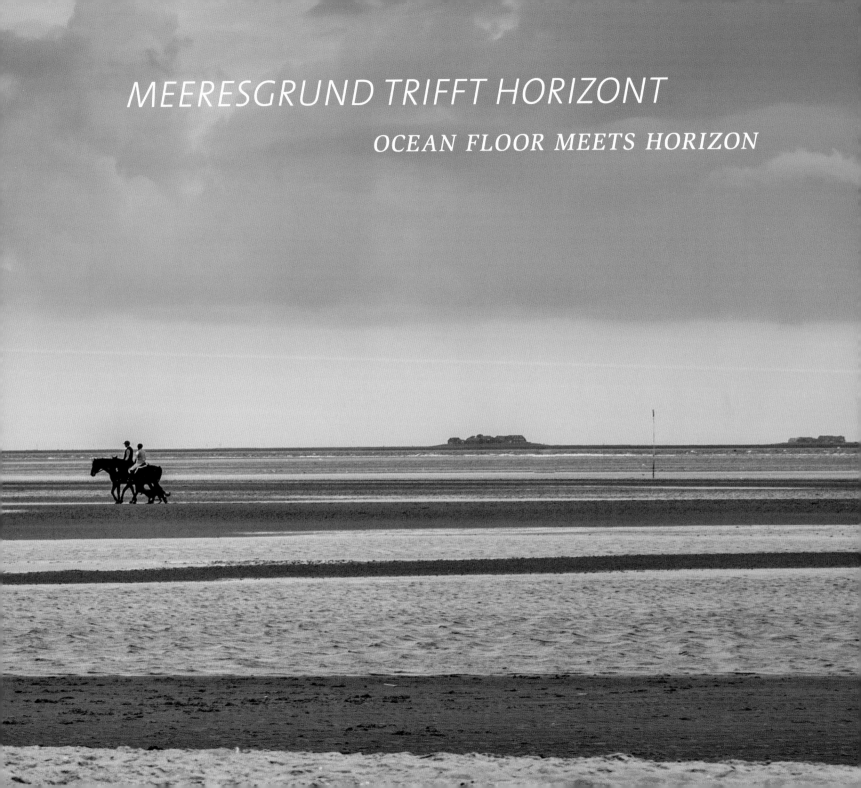

MEERESGRUND TRIFFT HORIZONT

OCEAN FLOOR MEETS HORIZON

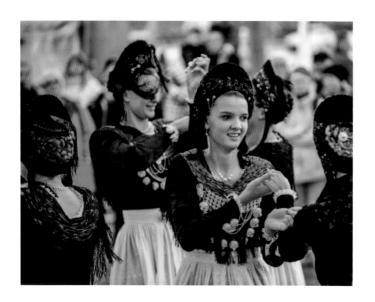

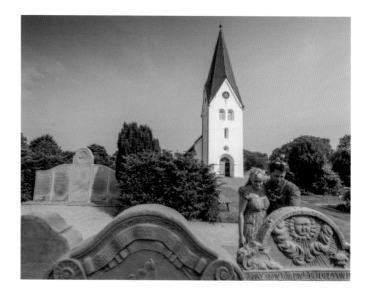

Die Tracht der NORDSEEINSEL FÖHR ist Botschafterin für die friesische Kultur und Tradition. Die wertvollen Stoffe mit ihrem filigranen Silberschmuck stellten einst den Wohlstand der Familien zur Schau und werden noch heute von Generation zu Generation vererbt. Das Anlegen der Tracht dauert einige Stunden und ist ohne Hilfe nicht zu bewältigen.

The native costume of the NORTH SEA ISLAND FÖHR has an ambassador function for Frisian culture and tradition. The expensive fabrics and delicate silver jewellery once indicated a family's wealth. Today, they are still handed down from generation to generation. It takes hours to put on a costume, and then only with help.

Auf dem Friedhof der St.-Clemens-Kirche im malerischen Friesendorf NEBEL auf AMRUM wird die jahrhundertealte Seefahrergeschichte der Insel wieder lebendig: 152 »sprechende Grabsteine« erzählen – künstlerisch in Stein gemeißelt – vom Leben der Walfänger, berichten von den Schicksalen der Schiffskapitäne und ihrer Familien.

The cemetery of St. Clemens' Church in the picturesque Frisian village of NEBEL on AMRUM brings the centuries-old history of the island alive: 152 »talking gravestones« tell stories of the whaler's lives, of the tragedies of skippers and their families – all artistically engraved in stone.

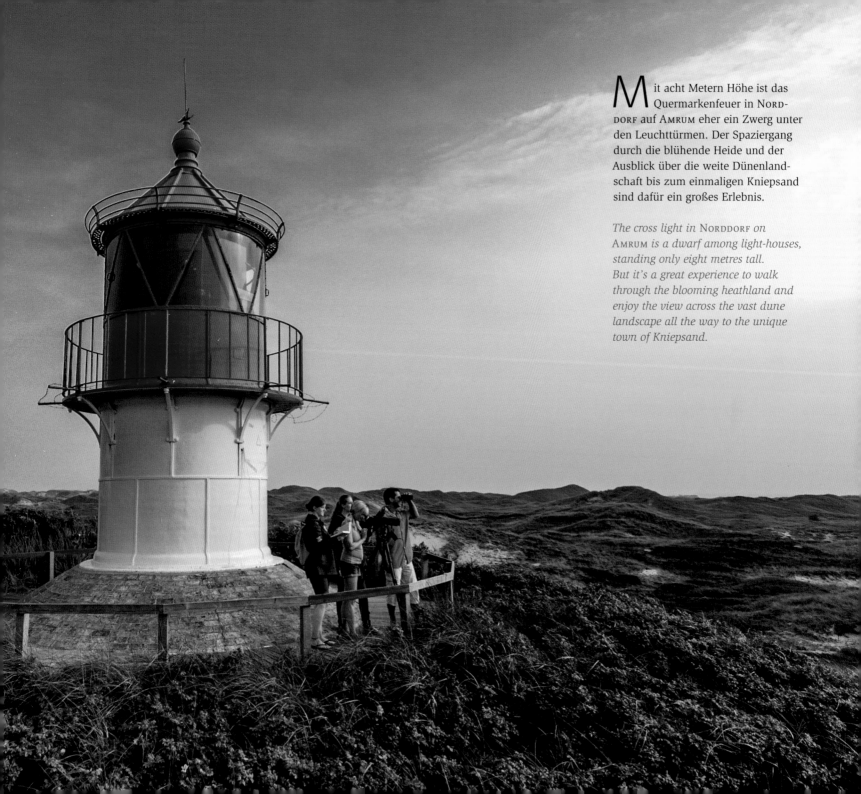

Mit acht Metern Höhe ist das Quermarkenfeuer in NORD-DORF auf AMRUM eher ein Zwerg unter den Leuchttürmen. Der Spaziergang durch die blühende Heide und der Ausblick über die weite Dünenland-schaft bis zum einmaligen Kniepsand sind dafür ein großes Erlebnis.

The cross light in NORDDORF on AMRUM is a dwarf among light-houses, standing only eight metres tall. But it's a great experience to walk through the blooming heathland and enjoy the view across the vast dune landscape all the way to the unique town of Kniepsand.

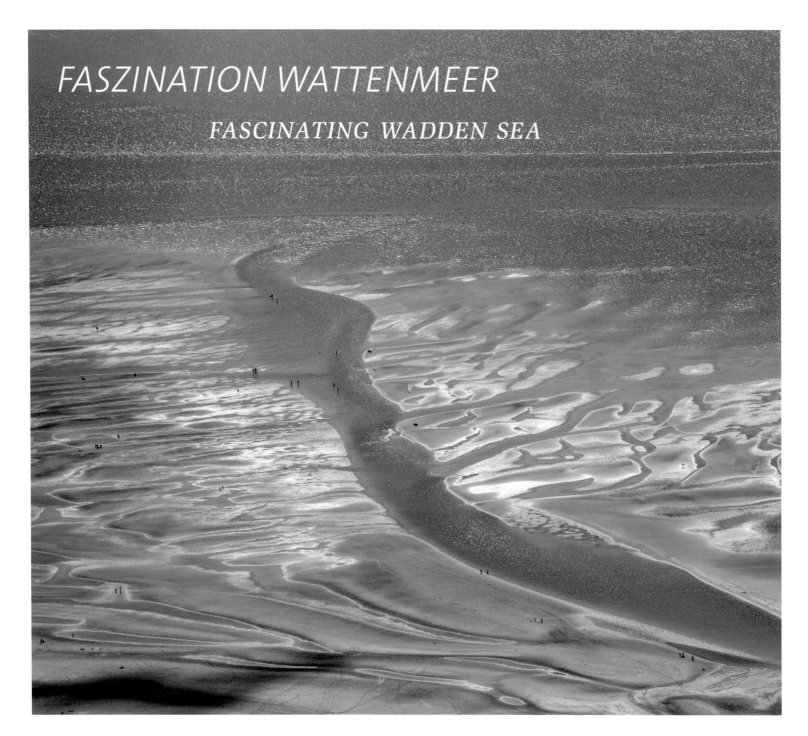

FASZINATION WATTENMEER

FASCINATING WADDEN SEA

D as UNESCO-Weltnaturerbe Wattenmeer ist eine
unvergleichliche Naturlandschaft, der Wandel vom
Meer zum Watt ein faszinierendes Schauspiel. Eine seltene
Vielfalt von mehr als 10.000 Tier- und Pflanzenarten hat
sich auf die extremen Bedingungen im Rhythmus der
Gezeiten angepasst.

Unesco Global Heritage site Wadden Sea is a landscape
beyond compare, and the ever-changing transformation
from sea to tidal flats makes a fascinating spectacle. More
than 10,000 animals and plants have adapted themselves to
the extreme conditions and the rhythm of the tides.

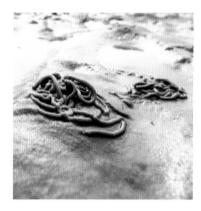

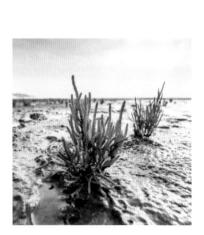

Zweimal am Tag wird der Queller
von den Nordseewellen überspült,
um im nächsten Moment ungeschützt
Wind und Sonne zu trotzen.

Submerged twice a day by the North
Sea, in the very next moment, the
salicornia stands tall and unprotected
from the wind and the sun.

Rund 25 Kilogramm Sand gräbt der
Wattwurm innerhalb eines Jahres
um und reichert so die oberen Watt-
schichten mit Nährstoffen an.

Lugworms dig up to 25 kilogram
of sand each year and help to supply
the upper levels of the tidal flats
with nutrients.

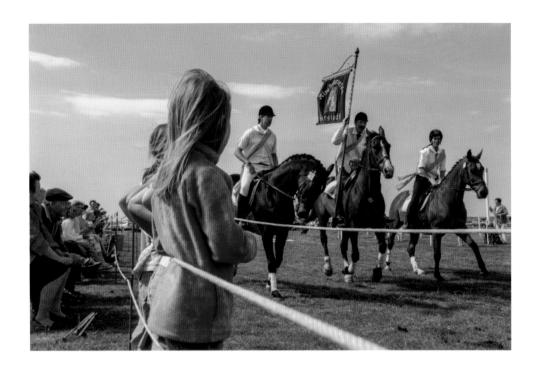

D as RINGREITEN ist im Norden eine jahrhundertealte Tradition und wird bereits im Kindesalter trainiert: Winzige Messingringe müssen dabei im Galopp mit einer Lanze aufgespießt werden.

RING RIDING is a centuries old tradition in the North and children start training young. The goal is to pick up small brass rings with a lance at galloping speed.

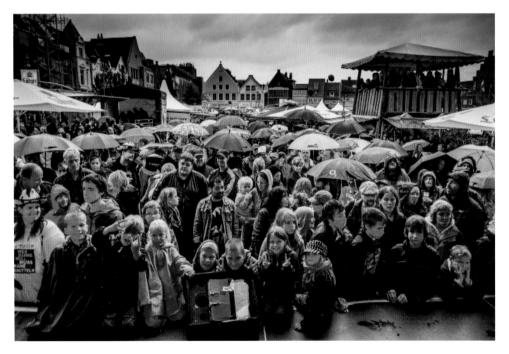

M it den HAFENTAGEN findet in HUSUM das größte Stadt-event an der Nordseeküste Schleswig-Holsteins statt: ein beliebtes Aus-flugsziel bei jedem Wetter.

One of the biggest events on the North Sea in Schleswig-Holstein is the HARBOUR DAYS in HUSUM: A popular excursion, whatever the weather.

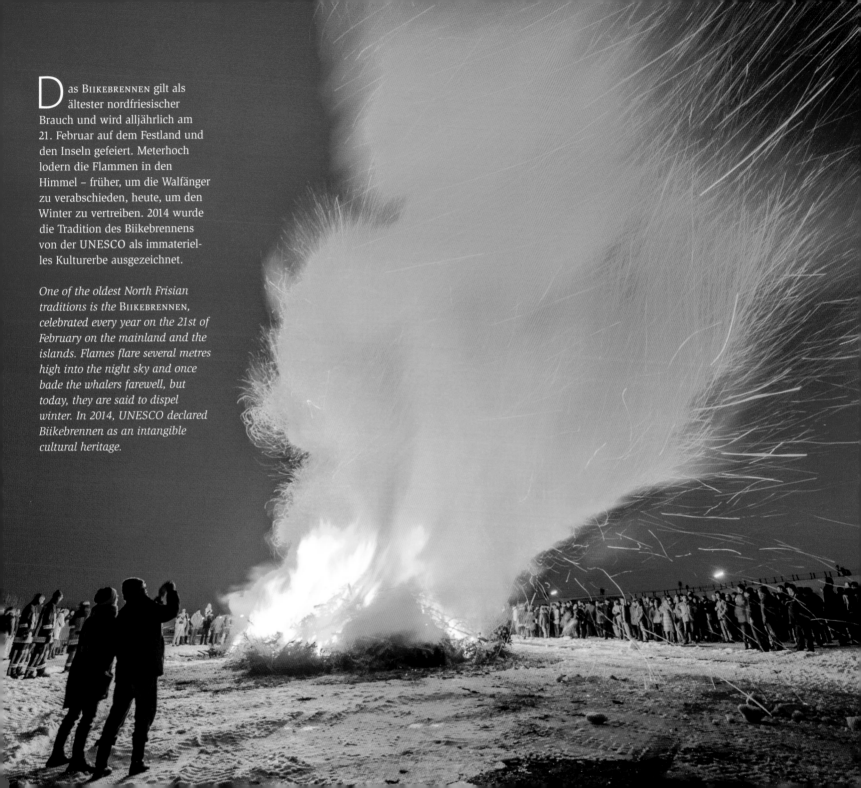

Das Biikebrennen gilt als ältester nordfriesischer Brauch und wird alljährlich am 21. Februar auf dem Festland und den Inseln gefeiert. Meterhoch lodern die Flammen in den Himmel – früher, um die Walfänger zu verabschieden, heute, um den Winter zu vertreiben. 2014 wurde die Tradition des Biikebrennens von der UNESCO als immaterielles Kulturerbe ausgezeichnet.

One of the oldest North Frisian traditions is the Biikebrennen, celebrated every year on the 21st of February on the mainland and the islands. Flames flare several metres high into the night sky and once bade the whalers farewell, but today, they are said to dispel winter. In 2014, UNESCO declared Biikebrennen as an intangible cultural heritage.

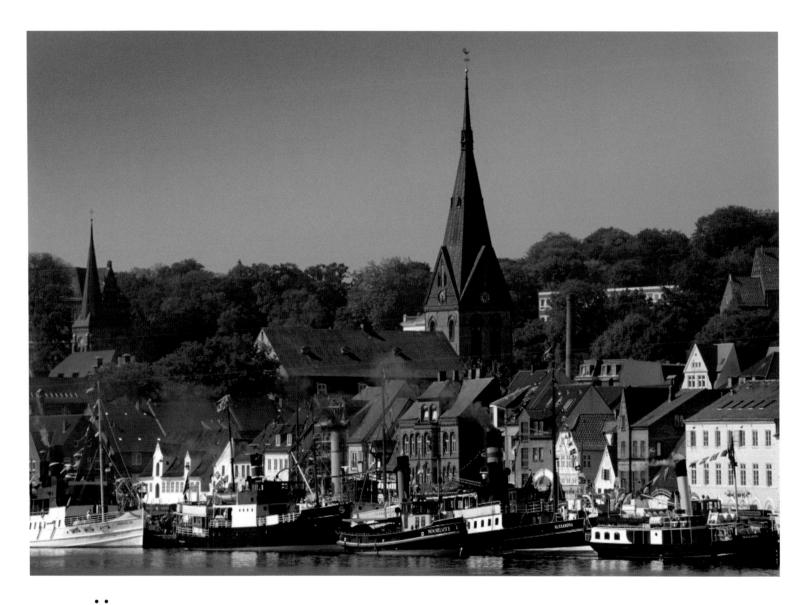

Über 40 Kilometer schlängelt sich die Flensburger
Förde, eines der schönsten Segelreviere Europas, tief
ins Schleswiger Land. An der westlichsten Spitze liegt die
Grenzstadt FLENSBURG. Viel Sehenswertes wie der Historische
Hafen, die hübsche Altstadt und die Rum- und Zuckermeile
erinnern an die Blütezeit Flensburgs als wichtigster Handels-
hafen Dänemarks und der Westindienflotte.

For 40 kilometres, the Flensburg fjord winds through the
»Schleswiger Land.« It is one of Europe's most beautiful
sailing areas. The border city of FLENSBURG is located on
its western tip. Sights such as the historic harbour, the
picturesque old city, and the rum and sugar mile recall of
Flensburg's heyday, when the city was the most important
port for Denmark and the West Indies fleet.

IM NORDEN DER OSTSEE

IN THE NORTH OF THE BALTIC SEA

Das Nordertor mit seinem auffälligen Treppengiebel ist eines der bekanntesten Wahrzeichen FLENSBURGS. Gebaut wurde es im Jahr 1595 als Kontrolltor für Einreisende. Die Nordseite des roten Backsteinbaus ziert neben dem Flensburger Stadtwappen und dem Wappen des dänischen Königs Christian VII. die wertvolle Erkenntnis »Friede ernährt, Unfriede verzehrt«.

One of the most recognisable buildings in FLENSBURG is the »Nordertor.« It was built in 1595 as a checkpoint for travellers. The northern side of the gate shows not only Flensburg's coat of arms, and that of Danish king Christian VII. It also bears a valuable inscription: »In peace we bloom, discord consumes.«

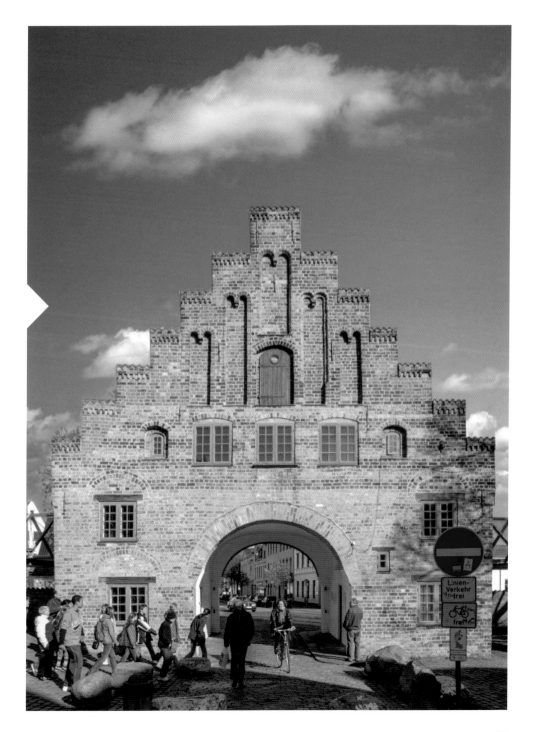

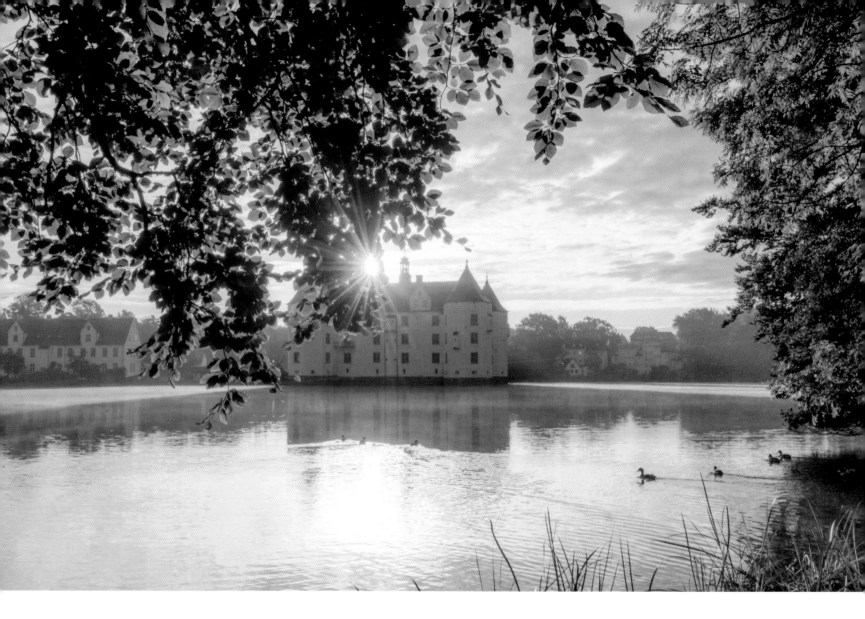

Wie ein Märchenschloss liegt das SCHLOSS GLÜCKSBURG, eingerahmt vom Grün des Waldes, im Schlossteich. Der prachtvolle Renaissancebau gehört zu den bedeutendsten Schlossanlagen Nordeuropas und ist als Museum der Öffentlichkeit zugänglich. Erbaut wurde es im Auftrag von Herzog Johann dem Jüngeren von 1583 bis 1587 – seinem Wahlspruch »Gott gebe Glück mit Frieden« verdankt das Schloss seinen Namen.

SCHLOSS GLÜCKSBURG emerges like a fairy tale castle from the middle of the lake, engulfed by the forest green. The renaissance building is one of the most important castles in Northern Europe and is open to the public as a museum. It was built by Count Johann the Younger between 1583 and 1587. The castle was named for its motto, »God grants happiness with peace.«

D ie HALBINSEL HOLNIS ragt bis zu
sechs Kilometer weit in die Flens-
burger Förde hinein und ist der nörd-
lichste Punkt der deutschen Ostseeküste.
Steilküste, Strände, kleine Waldstücke und
ausgedehnte Salzwiesen geben sich hier
ein reizvolles Stelldichein.

*HOLNIS PENINSULA reaches for up to
six kilometres into the Flensburg fjord
and marks the northernmost point of the
German Baltic Sea. Bluffs, beaches, small
forests, and widespread salt marshes
meet on this attractive peninsula.*

Im Mai zur Rapsblüte legt Schleswig-
Holstein sein leuchtend gelbes Kleid an
und strahlt mit den weißen Segeln auf
der Ostsee um die Wette.

*In May, when the rapeseed is in full bloom
in Schleswig-Holstein, the bright yellow veil
over the countryside competes in radiance
with the white sails on the Baltic Sea.*

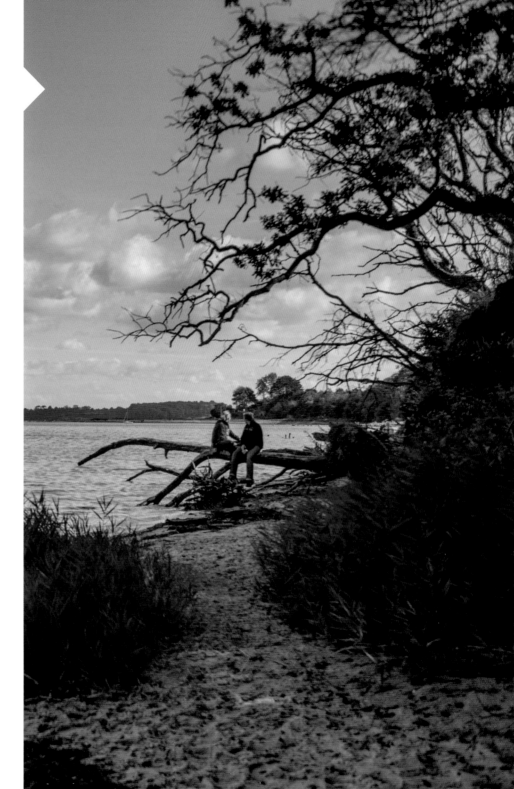

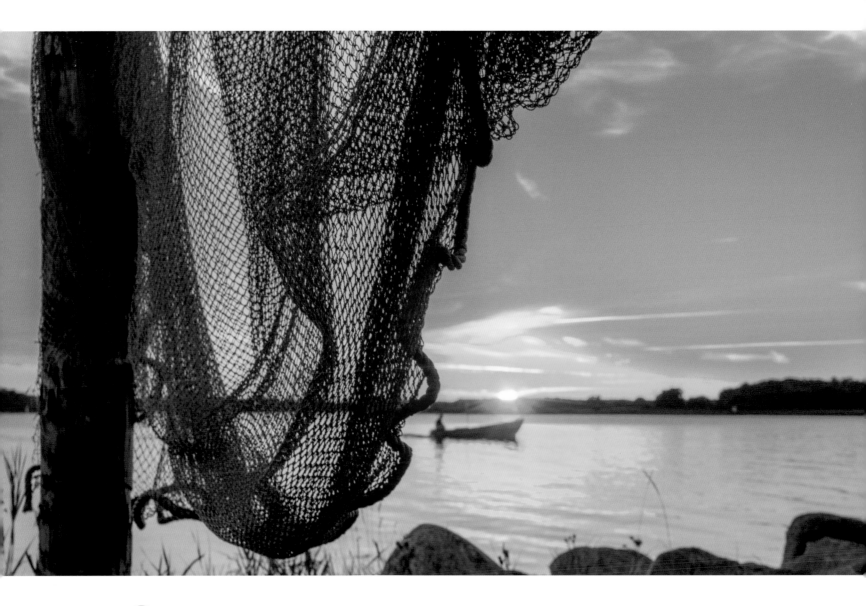

Sie ist kein Fluss, sondern ein Meeresarm der Ostsee: Kleine Häfen und beschauliche Dörfer säumen die Ufer der SCHLEI. Wie der ursprüngliche Fischerort MAAS-HOLM mit seinen alten Kahnstellen, auf einer Halbinsel an der Mündung in die Ostsee gelegen. Üppige Rosenbüsche blühen vor reetgedeckten Fischerkaten – munter und quirlig geht es im Jacht- und Fischereihafen zu.

The bank of the SCHLEI, which is not a river, but a sea arm of the Baltic, is lined with small harbours and villages. The fishing village MAASHOLM, with its old jetties, is located on a peninsula at the mouth of the Baltic. Lush rose bushes are in full bloom in front of old fishing cottages and a jolly and lively atmosphere pervades the marina and the fishing harbour.

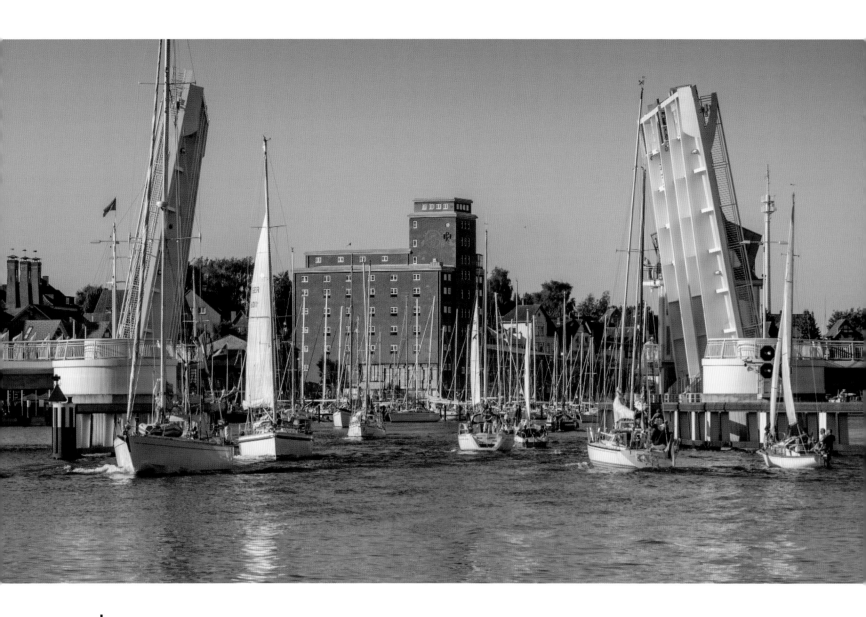

mmer um »Viertel vor« wird es geschäftig auf der Schlei, wenn sich die Klappbrücke vor KAPPELN öffnet und den Schiffen die Durchfahrt ermöglicht. Das hübsche Hafenstädtchen besticht mit seinem maritimen Flair und lädt zum Bummel durch seine kleinen Gassen ein. Ebenfalls zu bestaunen ist hier Europas letzter funktionsfähiger Heringszaun aus dem 15. Jahrhundert.

It always gets busy at »quarter to« on the Schlei: That's the time when KAPPELN's drawbridge opens up to let ships sail through. The picturesque harbour town boasts a maritime flair and invites a stroll along its small alleys. You can also admire Europe's last functioning herring fence from the 15th century.

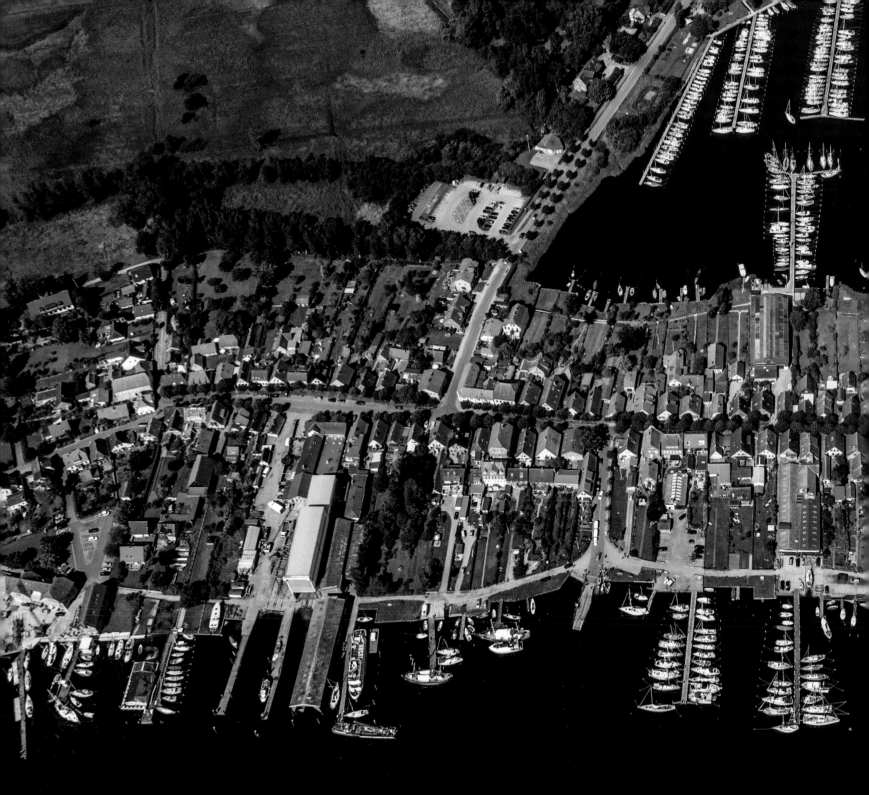

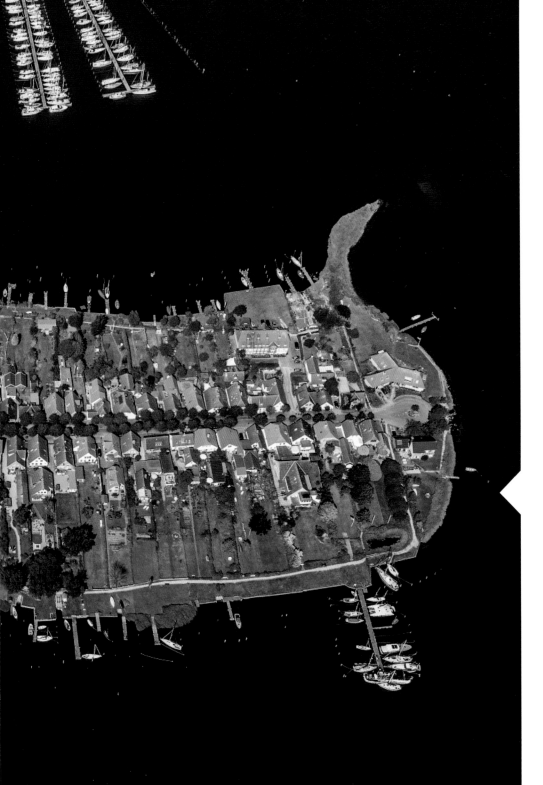

PERLE AM OSTSEEFJORD

PEARL ON THE BALTIC FJORD

M it etwas über 300 Einwohnern ist ARNIS die kleinste Stadt Deutschlands. Alte Fachwerkhäuser und Linden säumen die »Lange Straße«, welche die heutige Halbinsel durchzieht. Auf einem schönen Wanderweg immer am Wasser entlang lässt sich die »Perle der Schlei« in 30 Minuten umrunden.

Numbering just over 300 residents, ARNIS is the smallest town in Germany. Old timber-framed houses and linden trees line the »Lange Straße,« which spans today's peninsula. There is a beautiful path along the shore, that lets you hike around the »pearl of the Schlei« in 30 minutes.

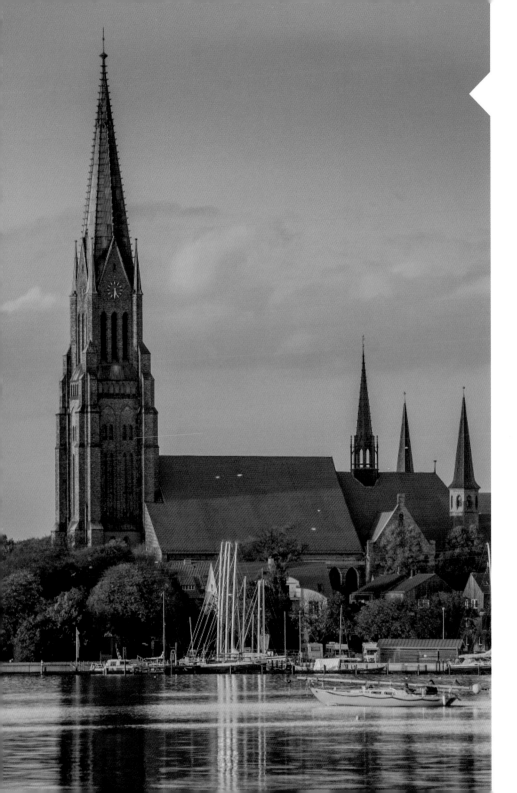

Am westlichen Ende der 42 Kilometer langen Schlei befindet sich eine der ältesten Städte Nordeuropas: Im Jahr 804 erstmalig als Siedlung »Sliasthorp« erwähnt, ist SCHLESWIG heute als Kulturstadt bekannt. Eindrucksvoll ragt der St.-Petri-Dom 112 Meter in die Höhe, sein berühmter Brüggemann-Altar gilt als Meisterwerk der Holzschnitzkunst.

One of the oldest cities in Northern Europe can be found on the western end of the 42-kilometre-long Schlei. The cultural city of SCHLESWIG was first mentioned in 804 as the settlement »Sliasthorp.« The tower of the St. Petri Cathedral is 112 impressive metres high, and its famous Brüggemann altar is considered a masterpiece in the art of woodcarving.

Am Haddebyer Noor vor den Toren Schleswigs lädt das archäologisch herausragende WIKINGER MUSEUM HAITHABU zu einer Zeitreise in die Vergangenheit der Nordmänner ein.

Right at the Haddebyer Noor outside of Schleswig, you will find the VIKING MUSEUM HAITHABU. It is archeologically outstanding and will take you on a trip back in time to the Norsemen.

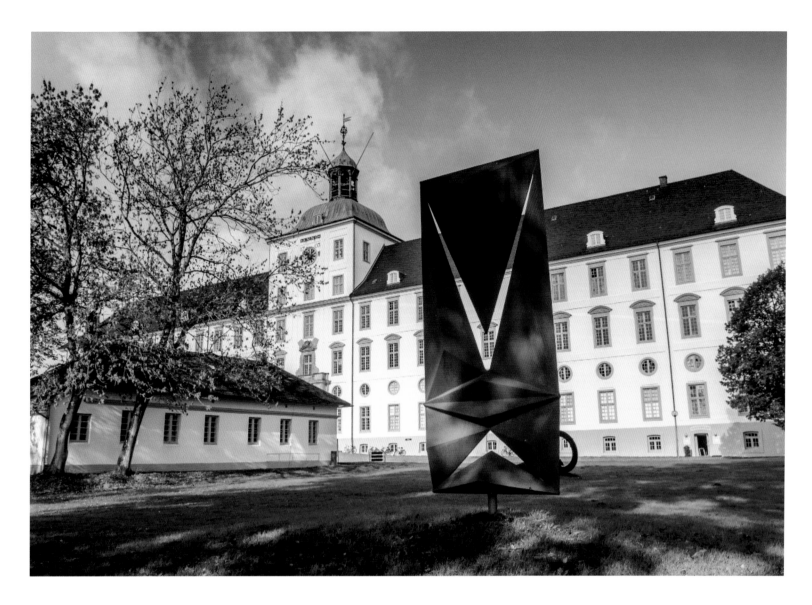

Einst war es die Residenz der Gottorfer Herzöge und das kulturelle Zentrum Nordeuropas; heute beherbergt das barocke SCHLOSS GOTTORF die Landesmuseen für Kunst und Kulturgeschichte sowie für Archäologie unter einem Dach. Zu den berühmtesten Anziehungspunkten gehören zweifelsohne das Nydam-Boot aus dem 17. Jahrhundert und die Moorleichen in der Eisenzeit-Ausstellung.

The residence of the Count of Gottdorf marked the cultural centre of Northern Europe in the past. Today, the CASTLE GOTTDORF houses the state's museum for Art and Cultural History, as well as Archaeology, all under one roof. Some of the main attractions are the Nydham boat from the 17th century, as well as the »bog men«, part of the Ice Age exhibition.

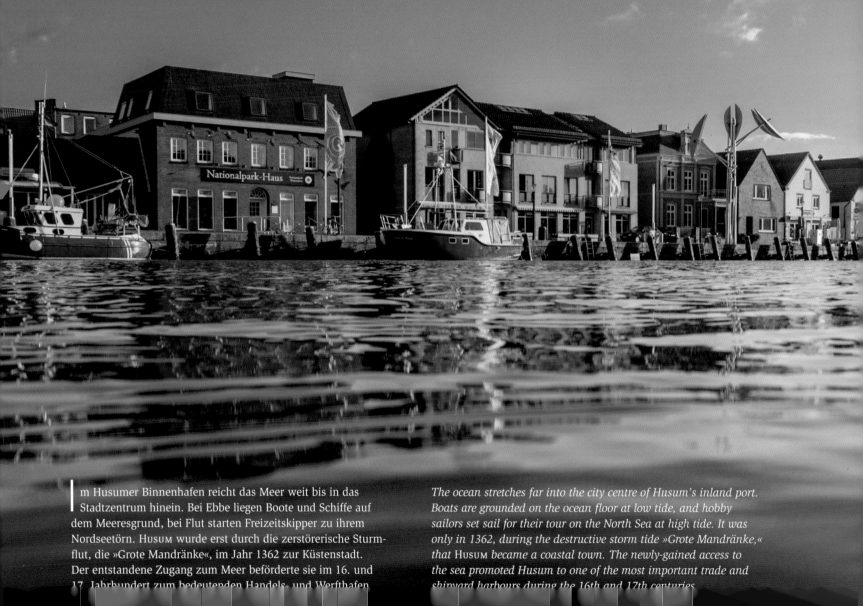

THEODOR STORMS »GRAUE STADT AM MEER«

THEODOR STORM'S »GREY CITY BY THE SEA«

m Husumer Binnenhafen reicht das Meer weit bis in das
Stadtzentrum hinein. Bei Ebbe liegen Boote und Schiffe auf
dem Meeresgrund, bei Flut starten Freizeitskipper zu ihrem
Nordseetörn. Husum wurde erst durch die zerstörerische Sturm-
flut, die »Grote Mandränke«, im Jahr 1362 zur Küstenstadt.
Der entstandene Zugang zum Meer beförderte sie im 16. und
17. Jahrhundert zum bedeutenden Handels- und Werfthafen.

*The ocean stretches far into the city centre of Husum's inland port.
Boats are grounded on the ocean floor at low tide, and hobby
sailors set sail for their tour on the North Sea at high tide. It was
only in 1362, during the destructive storm tide »Grote Mandränke,«
that Husum became a coastal town. The newly-gained access to
the sea promoted Husum to one of the most important trade and
shipyard harbours during the 16th and 17th centuries.*

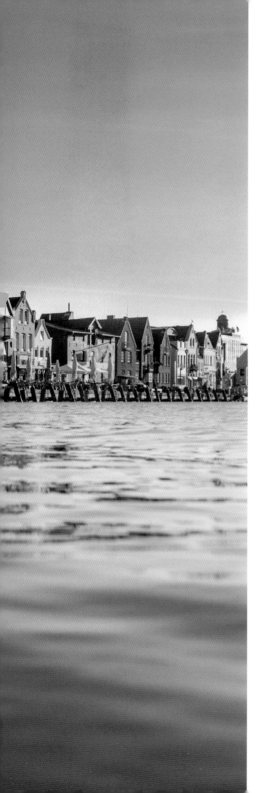

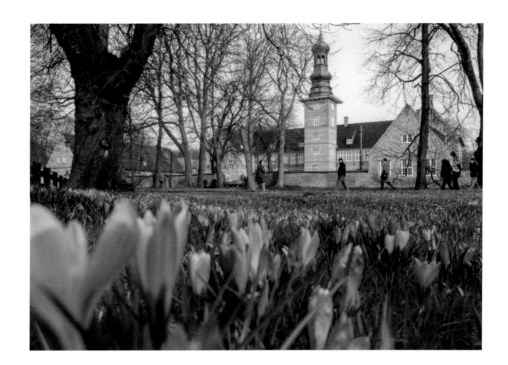

Das »Schloss vor Husum« – im 16. Jahrhundert gebaut und das einzige landesherrliche Schloss an der Westküste – liegt heute inmitten der Stadt. Ein Besuchermagnet und überregional bekannt ist das »Blütenwunder des Nordens«: Mehr als vier Millionen wild wachsende Krokusse verwandeln den Schlosspark im Frühjahr in ein zauberhaft violettes Blütenmeer.

»Husum's Castle,« built during the 16th century, was the only castle on the western coast belonging to a feudal lord. Today, it is located in the middle of the city. The famous »blossom spectacle« is a visitor's magnet nationwide. More than four million wild-growing crocuses transform the castle's garden into a magical carpet of violet blossoms.

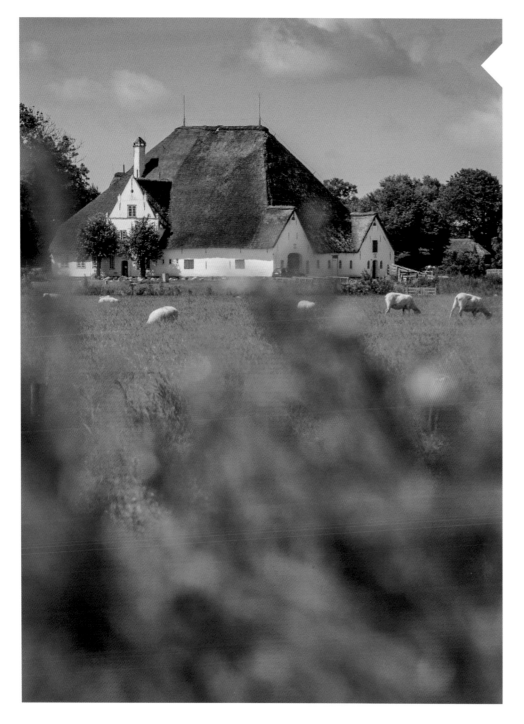

Die Bauform der imposanten Haubarge, die sich markant aus der Landschaft EIDERSTEDTS erheben, stammt aus Holland. Im 16. Jahrhundert gebaut, fanden Mensch, Vieh und Ernte vereint Platz unter dem gewaltigen reetgedeckten Dach. Von den ehemals 450 eindrucksvollen Zeugen der wirtschaftlichen Blütezeit stehen heute noch knapp 50. Der bekannteste ist der »Rote Haubarg« in WITZWORT, der entgegen seinem Namen weiß ist.

The design of the Haubarge, which rises prominently from the EIDERSTEDT landscape, derives from Holland. It was built in the 16th century, and people, livestock and the harvest alike found shelter under the massive reed-thatched of the roof. Only about 50 of the former 450 buildings that witnessed the economical heyday of the area have survived. The most famous is the »Rote Haubarg« in WITZWORT.

SCHÄTZE EIDERSTEDTS

TREASURES OF EIDERSTEDT

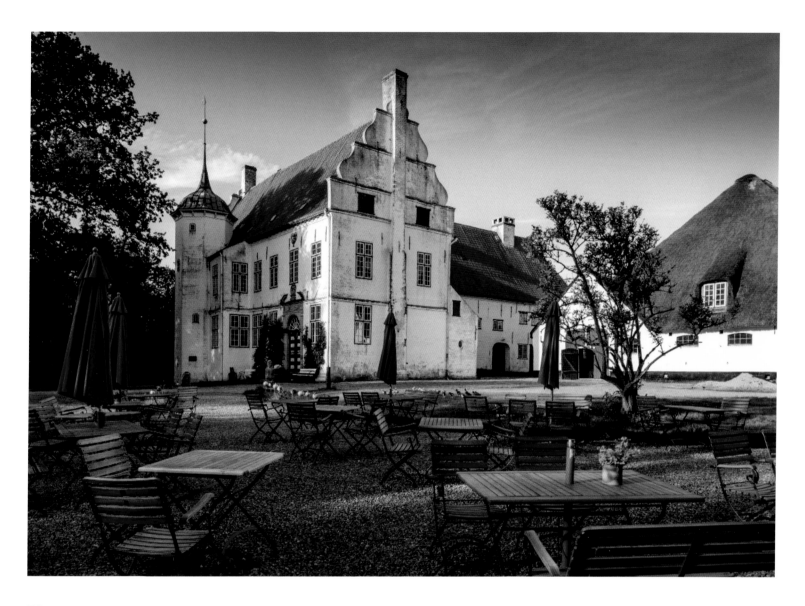

Das prachtvolle Herrenhaus HOYERSWORT ist der einzige ehemalige Adelssitz auf der Halbinsel Eiderstedt. Im 16. Jahrhundert vom Staller Caspar Hoyer errichtet und mit einem doppelten Wassergraben umgeben, zählt es zu den schönsten Renaissancebauten Schleswig-Holsteins. Das fast märchenhaft anmutende Areal umfasst neben dem herrschaftlichen Haus eine große Haubarg-Scheune, ein Museum und eine Töpferei.

The majestic mansion HOYERSWORT is the only noble estate on the Eiderstedt peninsula. Built in the 16th century by magistrate Caspar Hoyer, it was surrounded by a double moat. It is classified as one of the most beautiful renaissance buildings in Schleswig-Holstein. A Haubarg barn, a museum, and a pottery studio are located next to the mansion on the fairy-tale-like grounds.

Die EIDER, mit 188 Kilometern Schleswig-Holsteins längster Fluss, ist vielseitig wie kaum ein anderes Gewässer: Mal schlängelt sie sich schmal und geruhsam durch die idyllische Landschaft, mal dient sie großen Frachtschiffen als Wasserstraße. Die Eider entspringt südlich von Kiel, speist auf ihrem Weg Richtung Westen den Nord-Ostsee-Kanal, um ab Tönning ihren zwei Kilometer breiten Mündungstrichter zur Nordsee zu beginnen.

The river EIDER is Schleswig-Holstein's longest river, measuring 188 kilometres. It is more multifaceted than most other bodies of water – sometimes it runs, small and peaceful, through the idyllic landscape, sometimes it serves as a waterway for big container ships. The Eider River originates south of Kiel and feeds into the Kiel Canal on its way west. It begins its journey to the North Sea from Tönning, flowing onwards through the two-kilometre-wide estuary.

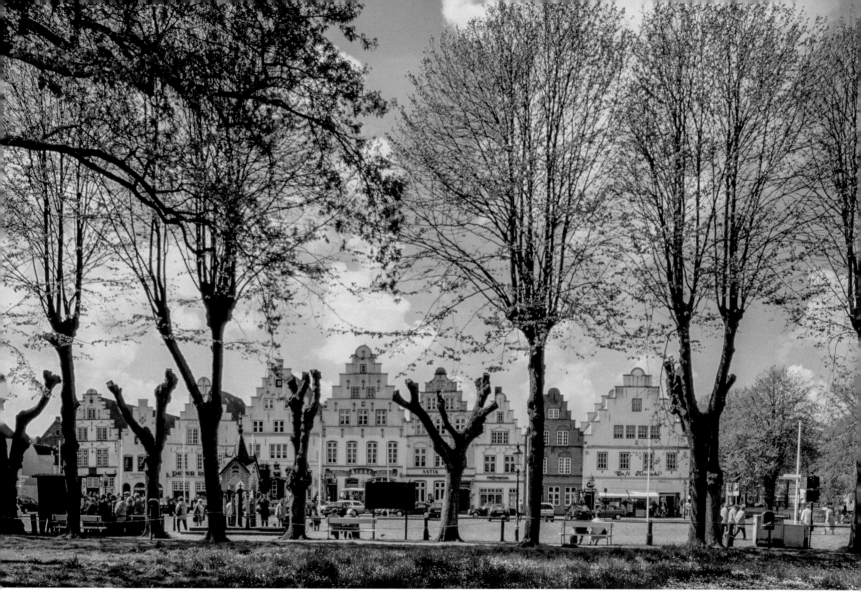

FRIEDRICHSTADT ist mit Treppengiebelhäusern, Brücken und
Grachten ein malerisches Kleinod. Der Grundstein für das
»Klein Amsterdam« am Zusammenfluss von Eider und Treene wurde
1621 gelegt: Um den Handel zu beleben, warb Herzog Friedrich III.
von Schleswig-Holstein-Gottorf mit Religionsfreiheit für die
Ansiedlung niederländischer Glaubensflüchtlinge. Als »Stadt der
Toleranz« ging Friedrichstadt damit in die Geschichte ein.

*Stepped gable houses, bridges, and town canals make
FRIEDRICHSTADT a picturesque gem. The foundation stones
for this »mini Amsterdam,« the place where the Eider and
Treene rivers meet, were laid in 1621. In order to revive trade,
Count Friedrich III of Schleswig-Holstein-Gottdorf assured
freedom of faith to the settlement of Dutch religious refugees.
So Friedrichstadt made history as a »town of tolerance.«*

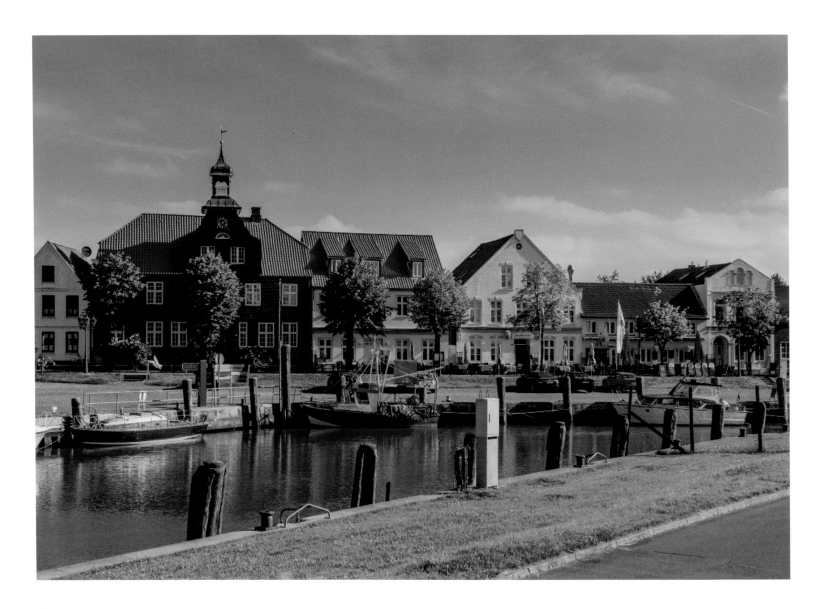

S chmucke Giebelhäuser säumen den pittoresken Hafen. Das historische Packhaus, der über 400 Jahre alte Marktplatz und der Schlosspark erinnern an die großen Zeiten des kleinen Städtchens. Bis zum 19. Jahrhundert war TÖNNING einer der wichtigsten Hafen- und Handelsorte an der Westküste. Seine Blütezeit erlebte der Nordseehafen durch den Bau des Eiderkanals im Jahr 1784, der erstmals den Weg zur Ostsee eröffnete.

Neat gable houses line the picturesque harbour. The historic packing plant, a marketplace, over 400 years old, and the palace garden recall a grand past. TÖNNING was one of the most important port and trading towns on the west coast. The North Sea harbour town experienced its florescence when the Eider Canal was built in 1784, opening the way to the Baltic Sea for the first time.

Das 1973 eingeweihte Sperrwerk am Mündungstrichter der Eider in die Nordsee ist das größte Küstenschutzbauwerk Deutschlands. Ausschlaggebend für den Jahrhundertbau war die Sturmflut von 1962, die selbst das etwa zehn Kilometer landeinwärts gelegene Tönning erfasste. Durch das EIDERSPERRWERK wurde die Seedeichlinie von rund 60 auf 4,8 Kilometer verkürzt. Fünf mächtige Sieltore schützen vor der Naturgewalt des Meeres.

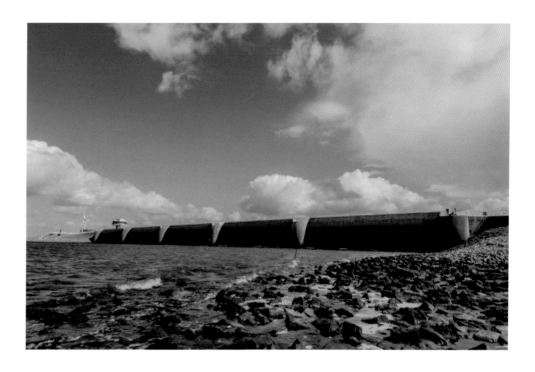

The flood barrier near the estuary of the Eider River represents the biggest coastal protection structure in Germany. It was built following the storm tide in 1962, which even reached the town of Tönning, 10 kilometres inland. Thanks to the EIDERSPERRWERK, *the dyke line along the North Sea could be reduced from 60 kilometres to 4.8 kilometres in length. Five mighty tidal gates now protect the region from the force of the sea.*

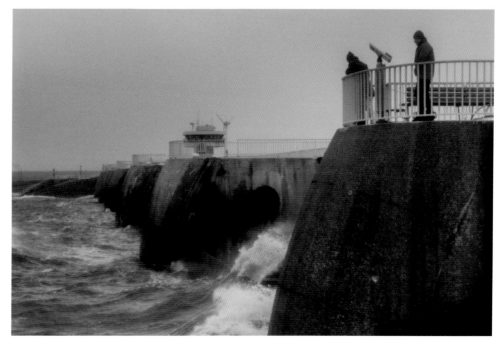

Der beliebte Ferienort St. Peter-Ording an der Spitze Eiderstedts lockt mit seinem zwölf Kilometer langen und bis zu zwei Kilometer breiten Sandstrand. Charakteristisches Markenzeichen sind die insgesamt 15 Pfahlbauten, die der Nordsee selbst bei Sturmflut trotzen. Die erste Hütte auf Stelzen wurde bereits 1911 errichtet, um Badegäste nach dem Schwimmen mit Speisen und Getränken zu versorgen. Da es dort »wat gift« (plattdeutsch für »etwas gibt«), wurde sie bezeichnenderweise »Giftbude« genannt.

A beach twelve kilometres long and up to two kilometres wide make St. Peter Ording, on the tip of Eiderstedt, a popular town to visit. Characteristic trademarks are 15 stilt houses, which defy even severe storm tides. The first building on stilts was built in 1911 to provide food and drinks for the bathers. Because of the Low German translation of »wat gift,« which means to »get something,« the houses are called »Giftbude« (»gift booths«).

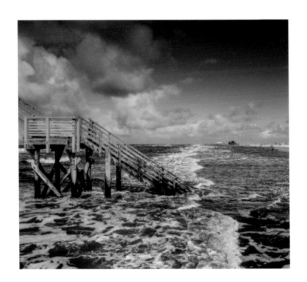

EUROPAS GRÖSSTE SANDKISTE

EUROPE'S BIGGEST SANDBOX

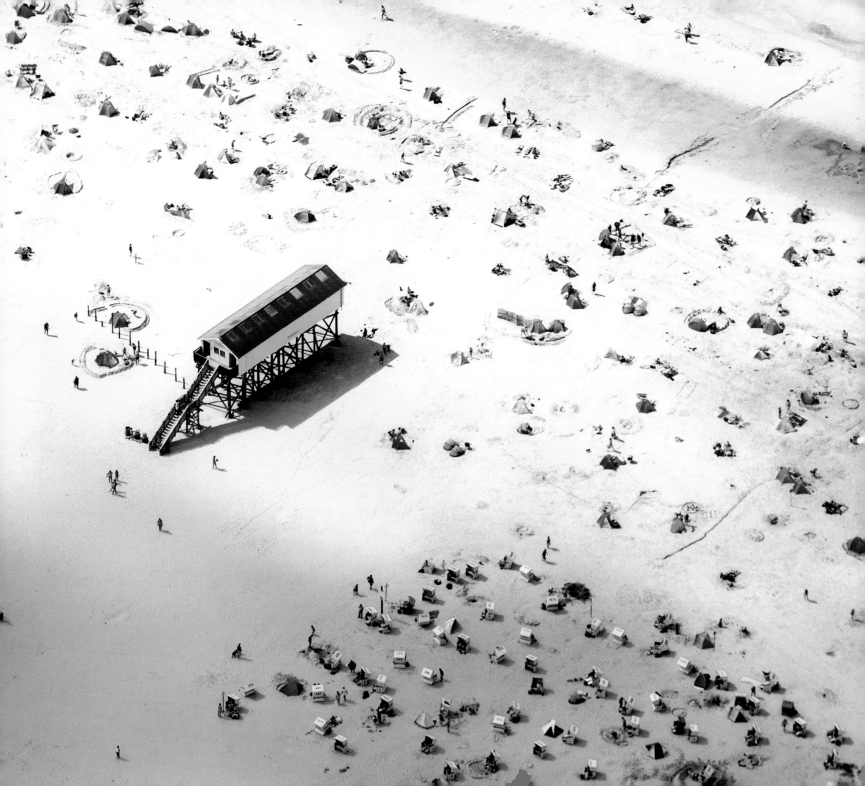

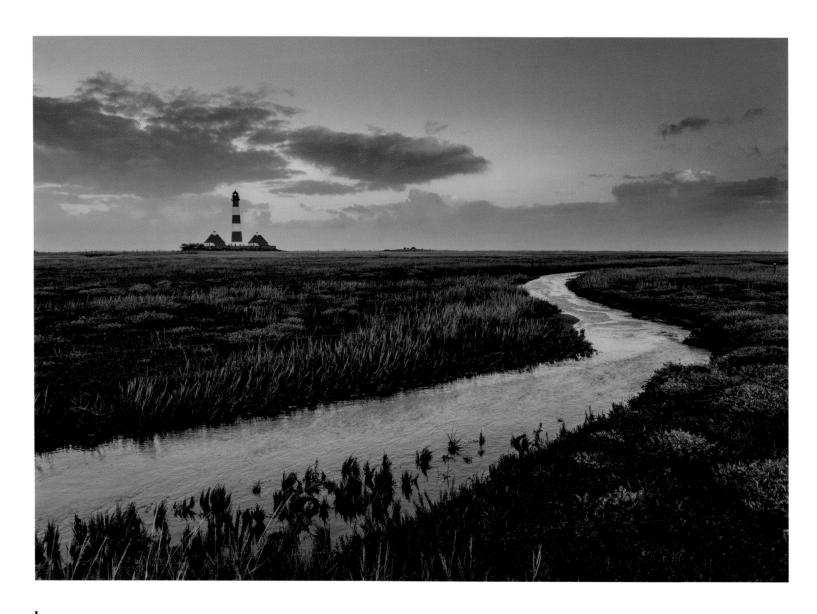

Im Nordwesten der Halbinsel Eiderstedt, eingebettet in saftig grüne Salzwiesen, steht ihr bekanntestes Wahrzeichen: der LEUCHTTURM WESTERHEVERSAND. Aufgrund des weichen Küstenbodens wurde sein Fundament auf 127 Eichenpfählen errichtet, der 41,5 Meter hohe Turm aus 608 gusseisernen Platten montiert. Nach 157 Stufen und neun Stockwerken wartet eine fantastische Aussicht über das Weltnaturerbe Wattenmeer.

Amidst moist green salt meadows on the north western peninsula of Eiderstedt, you can find a famous landmark: the LIGHTHOUSE OF WESTERHEVERSAND. The foundation for the 41.5-metre-high tower, assembled from 608 cast-iron sheets, was mounted on 127 oak stilts due to the soft coastal underground. A fantastic view across the Global Natural Heritage Site, the Wadden Sea, will reward you after mastering 157 steps and nine floors.

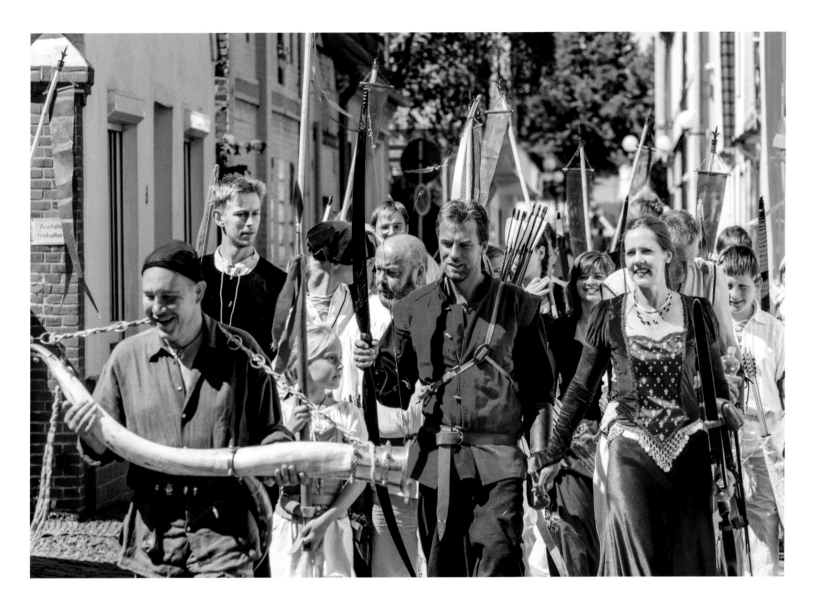

Am 13. Februar 1447 wurde auf dem Marktplatz in HEIDE – mit 4,7 Hektar der größte Deutschlands – das erste Dithmarscher Landrecht verkündet und allen Markttreibenden Frieden und Sicherheit garantiert. Zur Erinnerung an die Blütezeit der Bauernrepublik feiert die Kreisstadt Dithmarschens alle zwei Jahre im Sommer das Historienspektakel »Heider Marktfrieden«.

The first land law of Dithmarsch was announced on the 13th of February, 1447, at the market square in HEIDE (with 4.7 hectares, the biggest in Germany). It guaranteed peace and security to all tradespeople. Every two years, the city of Dithmarschen celebrates an historical spectacle called the »Heider Marktfrieden«, to remember the heyday of the peasant republic.

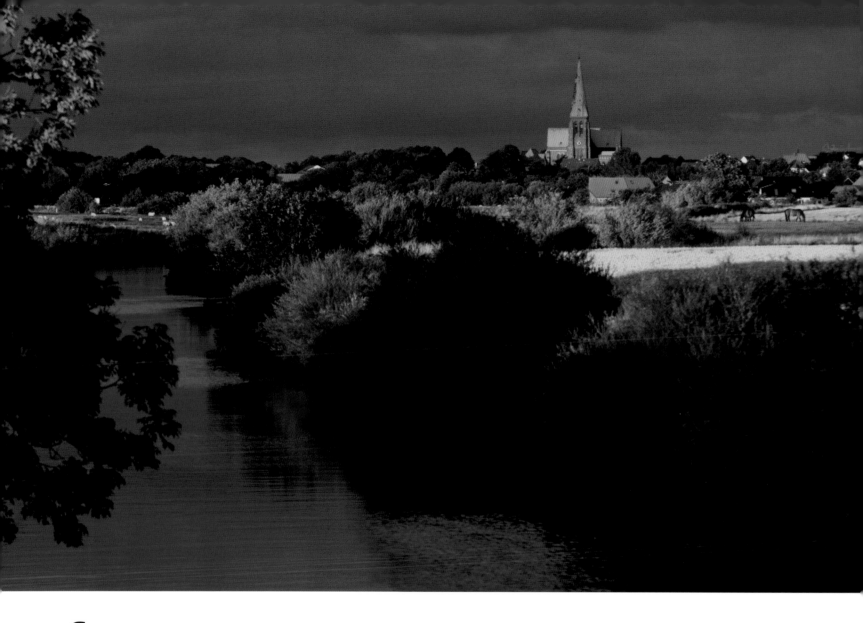

Sie heißt St. Johannis und ist eigentlich eine Pfarrkirche: Aufgrund ihrer Größe wird sie im Volksmund »Dom der Dithmarscher« genannt, obwohl MELDORF nie Bischofssitz war. Schon weit aus der Ferne ein Blickfang, gehört das um 1250 errichtete Wahrzeichen der Stadt zu den schönsten Bauwerken Norddeutschlands.

Called St. Johannis, this church is actually a parish church. Even though MELDORF was never a diocesan town, people often call it the »Cathedral of Dithmarschen.« The town's landmark, built in 1250, catches the eye from a distance, and can easily be added to the list of the most beautiful buildings in Northern Germany.

Das Nordsee-Heilbad Büsum bietet »Hafen satt«: den Fischereihafen mit einer der größten Krabbenkutterflotten Schleswig-Holsteins, den Jachthafen, den Hafen für die Ausflugsschiffe und den Museumshafen mit seinen liebevoll gepflegten historischen Schiffen. Anschließend warten die beliebten Büsumer Krabben, vielfältig und schmackhaft zubereitet.

The spa town of Büsum offers a »pure harbour feeling.« You can find the biggest crab fishing fleet in Schleswig-Holstein, a marina, the excursion-boat harbour, and the museum's harbour, with its lovingly restored historical ships. Make sure you try the popular Büsum crabs, deliciously prepared in many different styles.

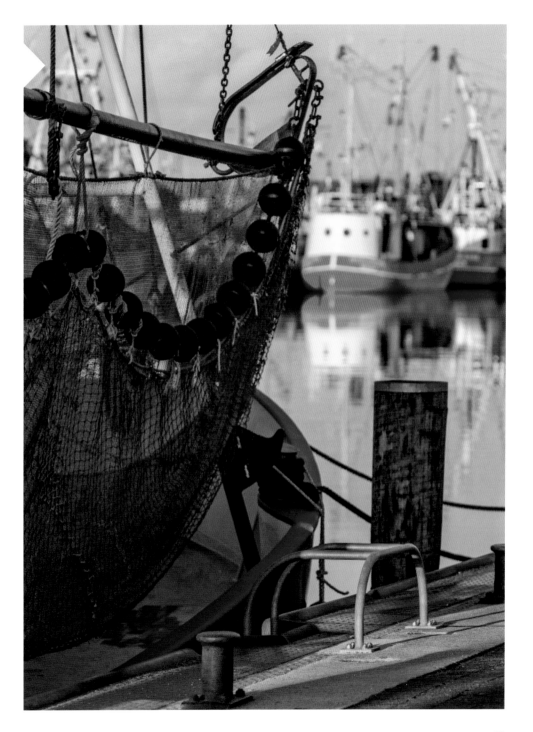

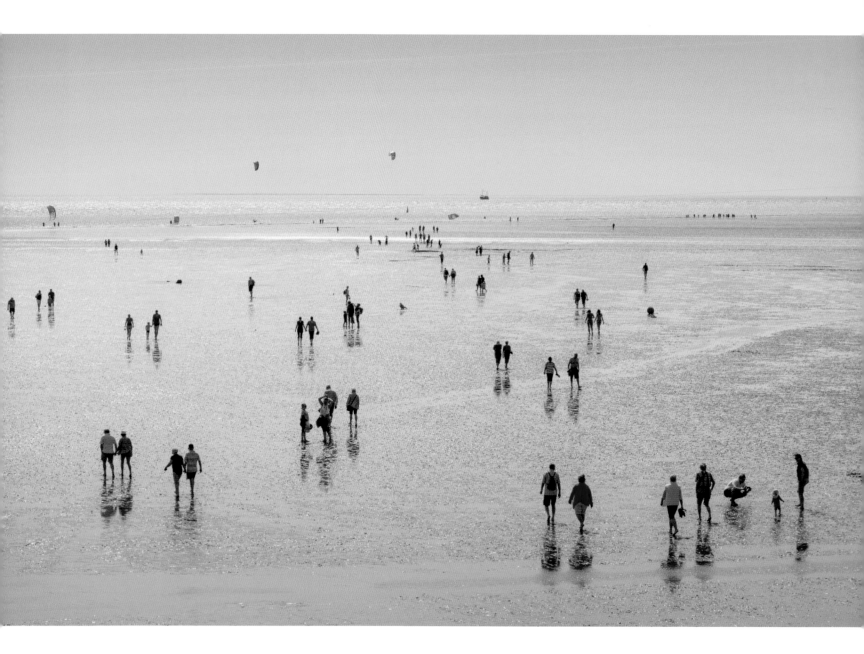

Wo eben noch Kinder in den Wellen tobten, ist jetzt das »watend begehbare Meer« zu erkunden. Zweimal am Tag fällt das Watt an der Nordsee trocken und gibt seine spannenden Geheimnisse auf dem Meeresgrund preis.

One minute, kids are playing in the waves, and in the next, you can explore the sea by wading in it. The Wadden Sea of the North Sea goes dry at low tide twice a day, revealing its secrets on the ocean floor.

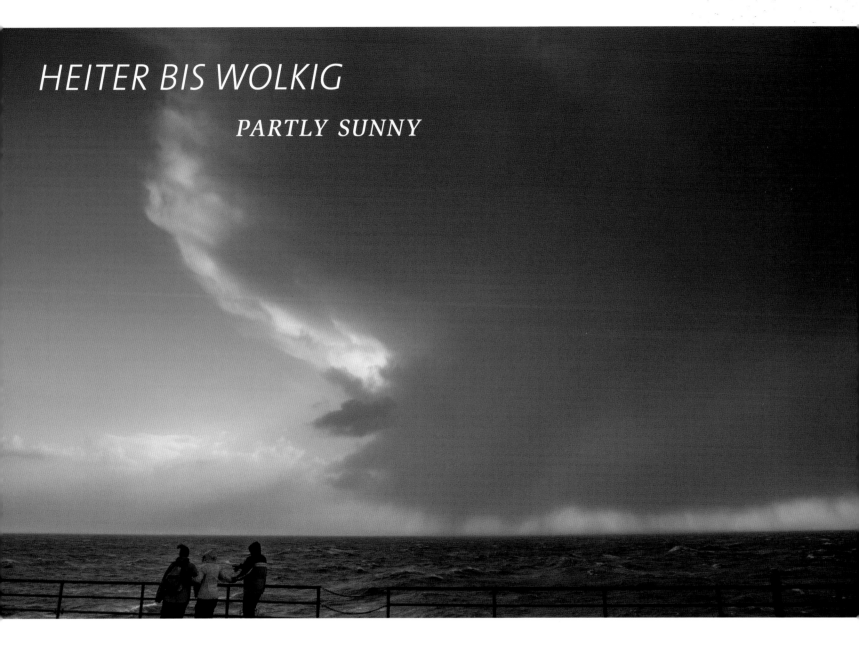

HEITER BIS WOLKIG

PARTLY SUNNY

Seit Menschengedenken ist die tosende See Fluch und Faszination zugleich. Mit modernem Küstenschutz ist man heute gegen die Fluten gewappnet; geblieben ist der Respekt, wenn der Sturm die gewaltigen Wassermassen gegen die Küste drückt.

The sea has been both a curse and a source of fascination since the beginning of time. Modern coastal protection measures ensure us safety from the waves; however, there is still a deep sense of respect when a storm front presses the masses of water again the coast.

Im Südwesten Dithmarschens, dem größten geschlossenen Kohlanbaugebiet Europas, unweit von Elbe und Nordsee liegt das beschauliche MARNE. Auf dem höchsten Punkt des Städtchens zwischen 1904 und 1906 erbaut, vereint die kreuzförmige Maria-Magdalenen-Kirche neugotische und neuromanische Elemente.

MARNE, a sleepy town southwest of Dithmarschen, and incidentally Europe's biggest cabbage-growing area, is not far away from the Elbe River and the North Sea. Maria-Magdalena Church was built on the highest point of the village between 1904 and 1906. The church is shaped like a cross and combines Neo-Gothic and Neo-Romanesque elements.

Auch der Norden kann Karneval: Mehr als 20.000 Besucher feiern in Marne traditionell den größten Rosenmontagsumzug Schleswig-Holsteins.

You can celebrate Mardi Gras even in the North: Marne welcomes more than 20,000 visitors for its traditional biggest Carnival parade in Schleswig-Holstein.

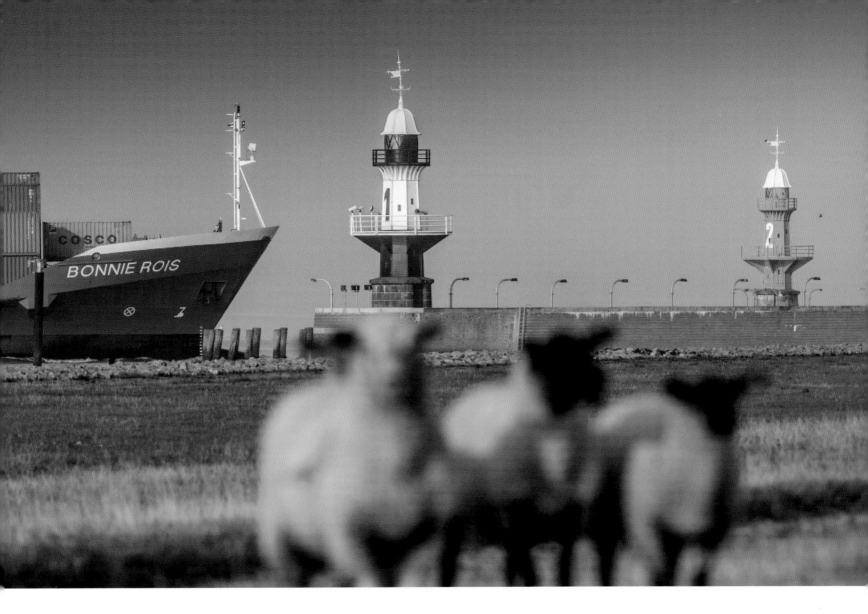

Der strategisch günstigen Lage an Unterelbe und Nord-Ostsee-Kanal verdankt der Seehafen in Brunsbüttel seine überragende Bedeutung: Mehr als 11,5 Millionen Tonnen Güter unterschiedlichster Art werden hier jährlich umgeschlagen. Gleichermaßen eindrucksvoll ist die gewaltige Schleusenanlage. Rund 100 Schiffe, von Containerriesen bis zu luxuriösen Kreuzfahrern, nutzen täglich die Abkürzung zwischen Nord- und Ostsee.

The seaport of Brunsbüttel is significant for its strategic and convenient location on the lower Elbe and the Kiel Canal. More than 11.5 million tons of different cargo is handled here every year. The massive lock is just as impressive. About 100 ships a day, from container giants to luxury cruise liners, make use of the shortcut between North Sea and the Baltic.

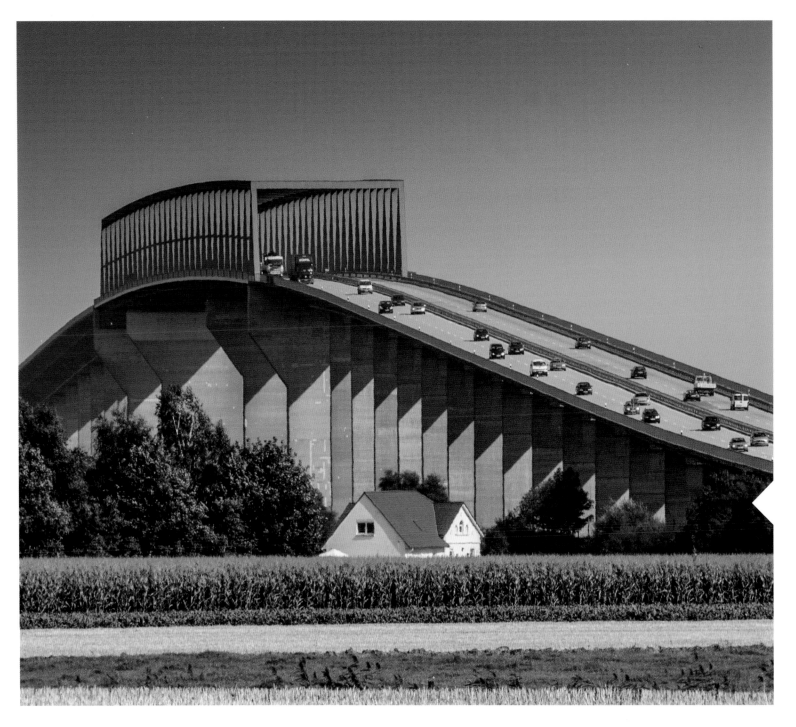

Als prachtvolle Konkurrenz zu Hamburg gedacht, gründete der dänische König Christian IV. im Jahr 1617 GLÜCKSTADT als uneinnehmbare Festungs- und Hafenstadt. Einst durch Walfang und Robbenjagd zu großem Wohlstand gekommen, ist das malerische Elb-städtchen heute für seinen nach alter Tradition hergestellten Matjes bekannt.

In 1617, the Danish king Christian IV founded the city of GLÜCKSTADT as a grand competitor to Hamburg and an impregnable fortress and port. Whaling and seal hunting brought in wealth, but today, the picturesque town is renowned for its traditional way of pickling herring.

Insgesamt zehn Brücken mit einer Durchfahrtshöhe von 40 Metern überspannen den Nord-Ostsee-Kanal. Die längste von ihnen, die Hochbrücke BRUNSBÜTTEL, misst beachtliche 2.831 Meter und ist damit die dritt-längste Brücke Deutschlands.

A total of ten bridges with a clearance height of 40 metres stretch over the Kiel Canal. The longest is the viaduct in BRUNSBÜTTEL, measuring an impressive 2,831 metres. This makes it the third-longest bridge in Germany.

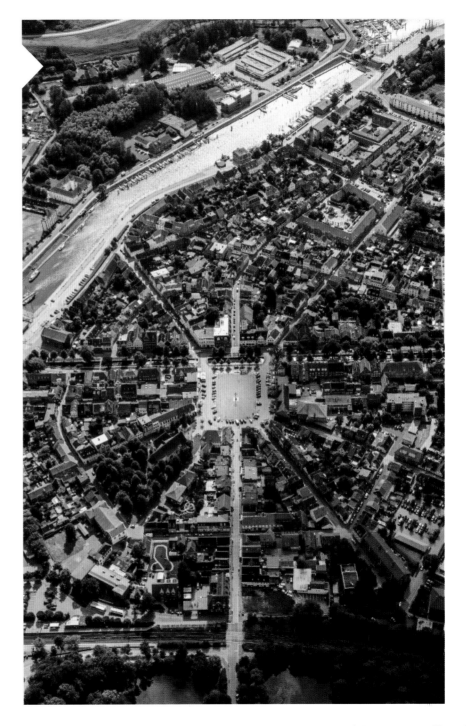

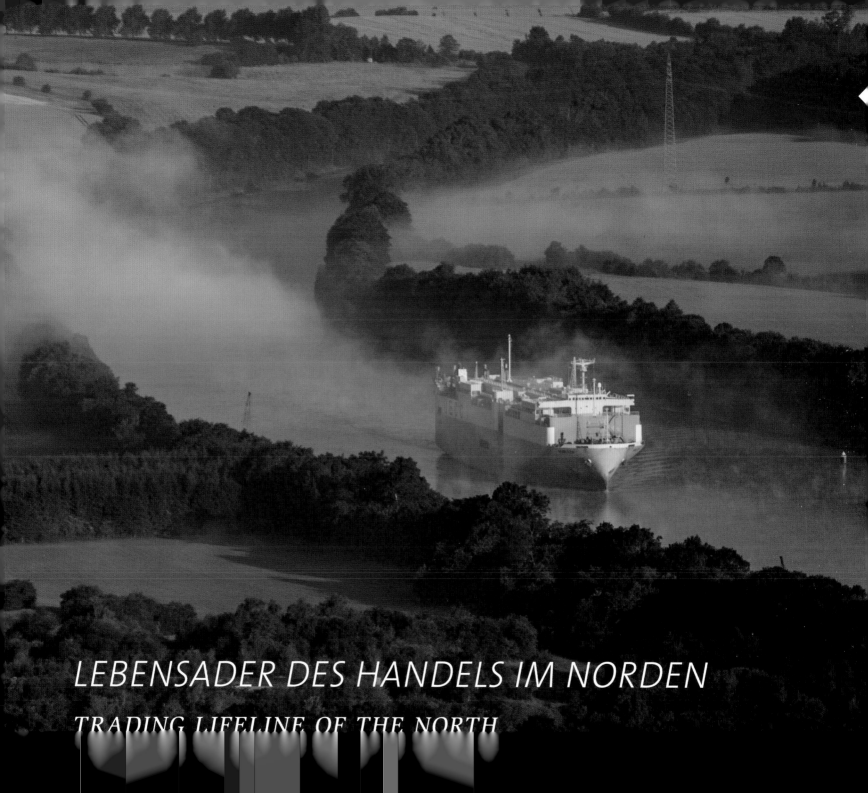

LEBENSADER DES HANDELS IM NORDEN

TRADING LIFELINE OF THE NORTH

Seit seiner feierlichen Eröffnung 1895 bleibt Schiffen der beschwerliche Umweg um die Nordspitze Dänemarks erspart: Der NORD-OSTSEE-KANAL wird jährlich von etwa 35.000 Schiffen genutzt und ist damit die meistbefahrene künstliche Wasserstraße der Welt.

Since its ceremonial inauguration in 1895, ships are spared the treacherous route around the northern tip of Denmark: 35,000 ships per year travel on the KIEL CANAL. This makes it the most-frequented artificial waterway worldwide.

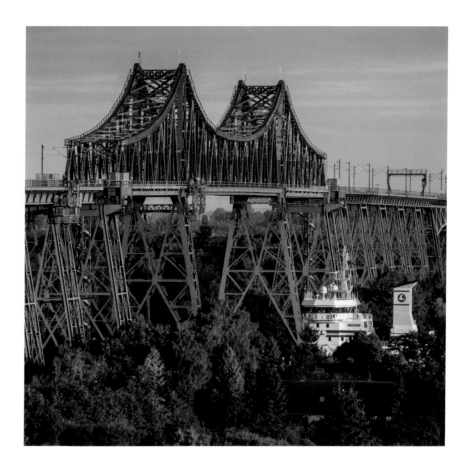

Fakten: Nord-Ostsee-Kanal

Länge	98,6 Kilometer
Wassertiefe	11 Meter
Durchfahrtshöhe	42 Meter
Höchstgeschwindigkeit	15 km/h
Fahrtzeit	6 bis 8 Stunden

Facts: Kiel Canal

Length	*98.6 kilometres*
Water depth	*11 metres*
Clearance	*42 metres*
Maximum speed	*15 km/h*
Travel time	*6 to 8 hours*

Die rund 2,5 Kilometer lange Eisenbahn-Hochbrücke in RENDSBURG zählt zu den bedeutendsten technischen Baudenkmalen Deutschlands. Für ihre Fertigstellung im Jahr 1913 wurden insgesamt 17.700 Tonnen Stahl mit 3,2 Millionen Nieten zusammengefügt. Im Viertelstundentakt fährt die »Eiserne Lady«, eine der acht letzten Schwebefähren der Welt, von einem Ufer des Nord-Ostsee-Kanals zum anderen.

The railway viaduct in RENDSBURG is 2.5 kilometres long and counts as one of the most important technical historic monuments in Germany. For its completion in 1913, a total of 17,700 tons of steel were assembled with 3.2 million rivets. The »Iron Lady« runs every quarter hour from one bank of the Kiel Canal to the other, and is one of the last eight remaining suspension ferries worldwide.

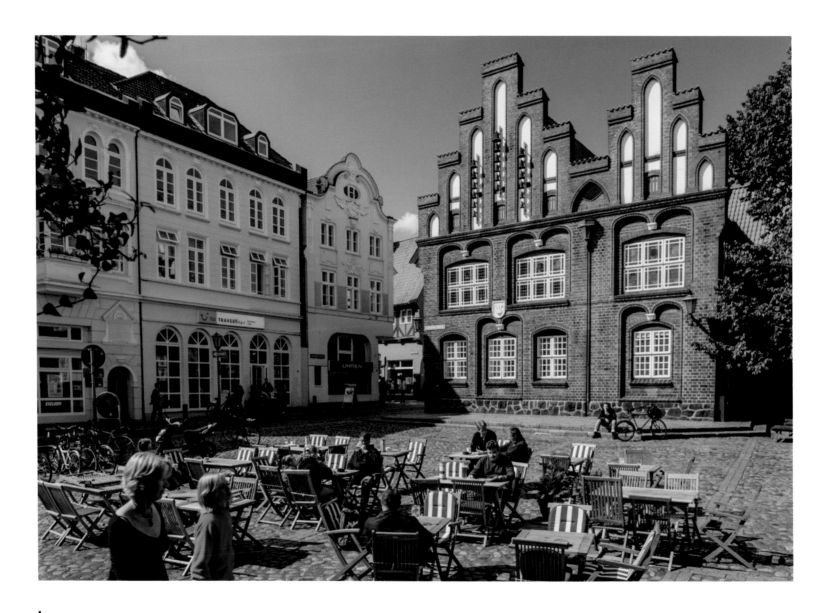

Im Herzen Schleswig-Holsteins blickt Rendsburg als ehemals bedeutender Hafen- und Handelsplatz und Verbindung zwischen Nord und Süd, Ost und West auf eine wechselvolle Geschichte zurück. Die heutige Altstadt mit ihren hübschen historischen Bauten wurde auf einer Insel in der Eider angelegt und im späten 17. Jahrhundert von dänischen Königen zur stärksten Festung nach Kopenhagen ausgebaut.

Rendsburg, *located in the heart of Schleswig-Holstein, can look back on a history full of transformations. It used to be an important port and trade centre, as well as a connection between north and south and east and west. Today's old town, with its pretty historic buildings, was once a development on the middle of an island in the Eider River. In the late 17th Century, the Danish king upgraded this development to become the strongest fortress next to Copenhagen.*

Seen, Wälder, Wiesen und Moore: Der NATURPARK WESTENSEE lockt mit einem reizvollen Mosaik unterschiedlichster Landschaften. Viele seltene und geschützte Vogelarten wie Seeadler, Kormoran, Uhu und Eisvogel haben hier ein ungestörtes Zuhause gefunden.

Lakes, forests, meadows, and marshland: NATURE PARK WESTENSEE offers an attractive mosaic of different landscapes. Rare and protected birds like white-tailed eagles, cormorants, owls, and kingfishers have found a peaceful home here.

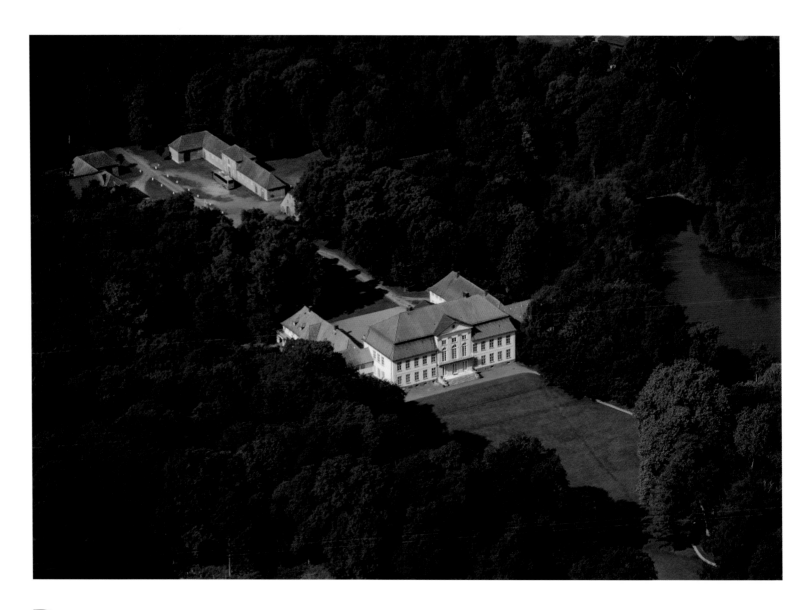

Das Gut Emkendorf gilt als eines der schönsten Güter Schleswig-Holsteins. Debattierkreise mit illustren Gästen wie Matthias Claudius und Friedrich Gottlieb Klopstock brachten dem schmucken Herrenhaus im 18. Jahrhundert den Beinamen »Weimar des Nordens« ein. Als Spielstätte des Schleswig-Holstein Musik Festivals wird der historische Musenort jedes Jahr im Sommer wieder lebendig.

Gut Emkendorf is one of the most beautiful manors in Schleswig-Holstein. Debating societies with illustrious guests like Matthias Claudius and Friedrich Gottlieb Klopstock inspired the nickname »Weimar of the North« during the 18th century. The muse is revived each summer on this historic site, during the Schleswig-Holstein Music Festival.

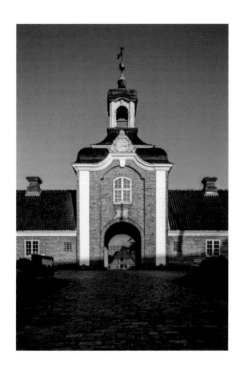

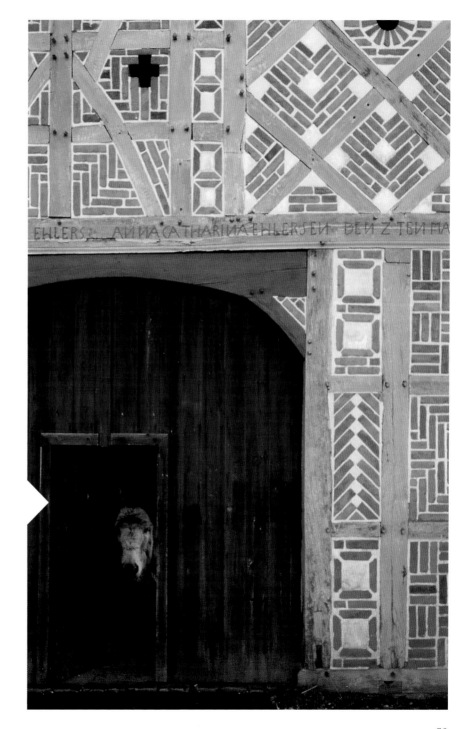

Das Freilichtmuseum in MOLFSEE, Landesmuseum für Volkskunde, ist das größte seiner Art in Norddeutschland. Auf dem weitläufigen Gelände mit Wiesen und Feldern und in über 70 historischen Gebäuden ist die Kulturgeschichte des ländlichen Schleswig-Holsteins hautnah erlebbar.

The open-air museum in MOLFSEE, the State Museum for Folklore, is the biggest of its kind in Northern Germany. Schleswig-Holstein's cultural history is tangible on the vast grounds, boasting meadows, fields, and over 70 historic buildings.

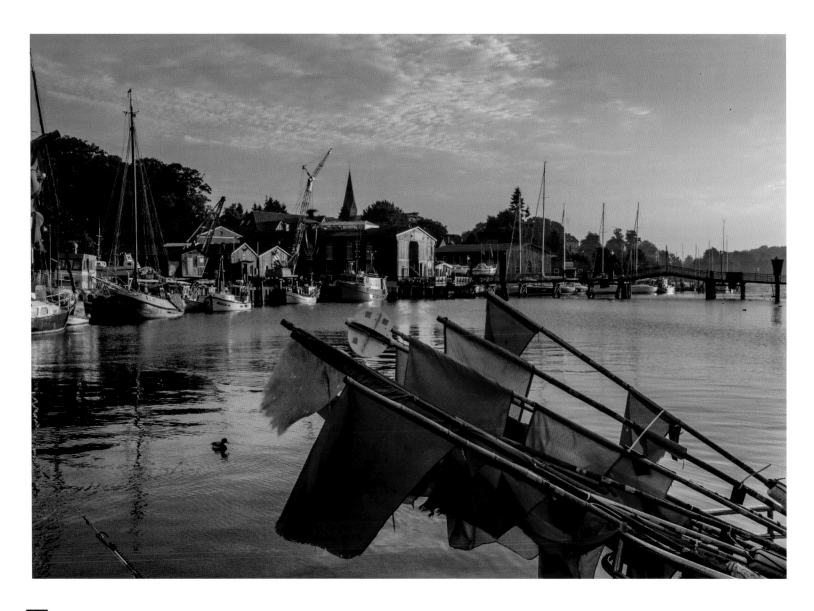

Traditionssegler und Fischkutter bestimmen das charmante Stadtbild. Vom Binnenhafen schlängeln sich enge Gassen mit hübsch restaurierten Fischerhäuschen durch die beschauliche Altstadt. ECKERNFÖRDE ist die Heimat der »Kieler Sprotte«. In dem früheren Fischerort wird heute noch der silbrige kleine Fisch traditionell geräuchert und in Gold verwandelt.

Traditional sailing yachts and fishing boats dominate the view of this charming cityscape. Small alleys with beautifully restored fishing cottages wind their way from the inner port to the small old town. ECKERNFÖRDE is home of the »Kieler Sprotte«. The small fish, silver in colour when caught, is cured and turned into gold in this former fishing village.

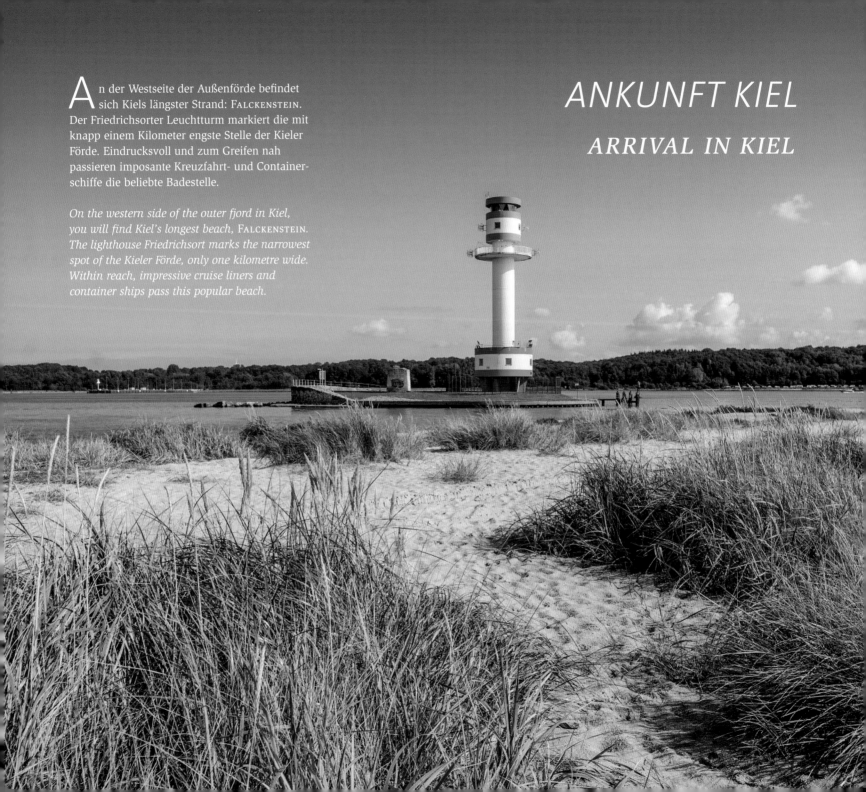

ANKUNFT KIEL

ARRIVAL IN KIEL

An der Westseite der Außenförde befindet sich Kiels längster Strand: FALCKENSTEIN. Der Friedrichsorter Leuchtturm markiert die mit knapp einem Kilometer engste Stelle der Kieler Förde. Eindrucksvoll und zum Greifen nah passieren imposante Kreuzfahrt- und Container- schiffe die beliebte Badestelle.

On the western side of the outer fjord in Kiel, you will find Kiel's longest beach, FALCKENSTEIN. The lighthouse Friedrichsort marks the narrowest spot of the Kieler Förde, only one kilometre wide. Within reach, impressive cruise liners and container ships pass this popular beach.

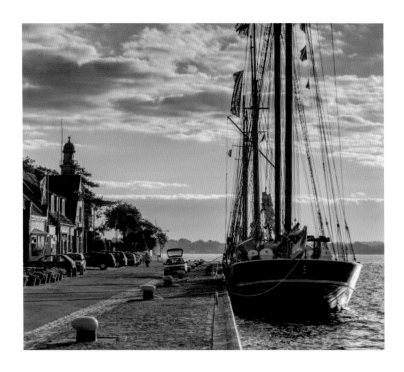

Nostalgische Hafenatmosphäre versprüht der Tiessenkai in KIEL-HOLTENAU mit seinen kleinen Kontorhäusern und dem ehemaligen Packhaus. Alte Fracht-segler liegen direkt am Kai. Containerriesen verlassen den Kanal in Richtung Horizont. In den urigen Räumen des früheren Schiffs-ausrüsters Hermann Tiessen lädt heute ein Café zur geselligen Einkehr ein.

Old office buildings and the old packing plant ooze nostalgic harbour atmosphere around the Tiessen quay in KIEL-HOLTENAU. Old freight yachts are moored straight to the quay. Container giants depart the canal for the horizon. These days, the quaint rooms of the former ship chandler, Hermann Tiessen, have been converted into a cosy café.

Der HOLTENAUER LEUCHTTURM – einer der schönsten Deutschlands – ist Seezeichen und Gedenkstätte in einem: 1895 an der Zufahrt zum Nord-Ostsee-Kanal in Betrieb genommen, wird in der achteckigen »Drei-Kaiser-Halle« an die während des Kanalbaus amtierenden deutschen Kaiser Wilhelm I., Friedrich III. und Wilhelm II. erinnert.

HOLTENAU'S LIGHTHOUSE is one of the prettiest in Germany and represents both a marine landmark and a memorial. It was inaugurated in 1895 – right at the entrance to the Kiel Canal. Inside the octagonal »three-emperor-hall« it memorialises those three German emperors reigning during the building of the canal: Wilhelm I., Friedrich II. and Wilhelm II.

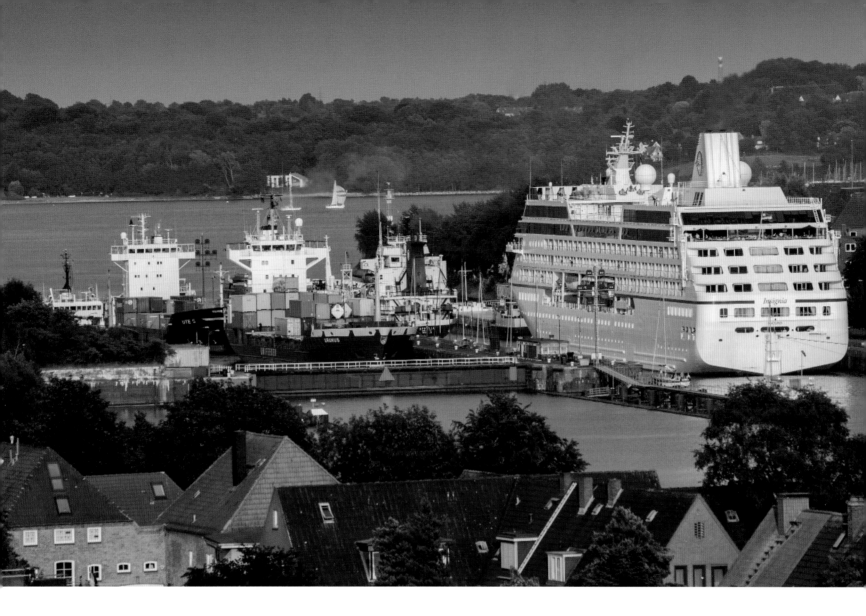

Etwa 20 Zentimeter Höhenwasserunterschied müssen zwischen Nord-Ostsee-Kanal und Kieler Förde ausgeglichen werden. Die spektakuläre Schleusung in Kiel-Holtenau dauert durchschnittlich 30 Minuten und kann aus nächster Nähe von einer Aussichtsplattform verfolgt werden.

About 20 centimetres of water height must be levelled between Kiel Canal and Kieler Förde. It only takes an average of 30 minutes for the locking of the ships in Kiel-Holtenau, and the process can be observed closely from a nearby viewing platform.

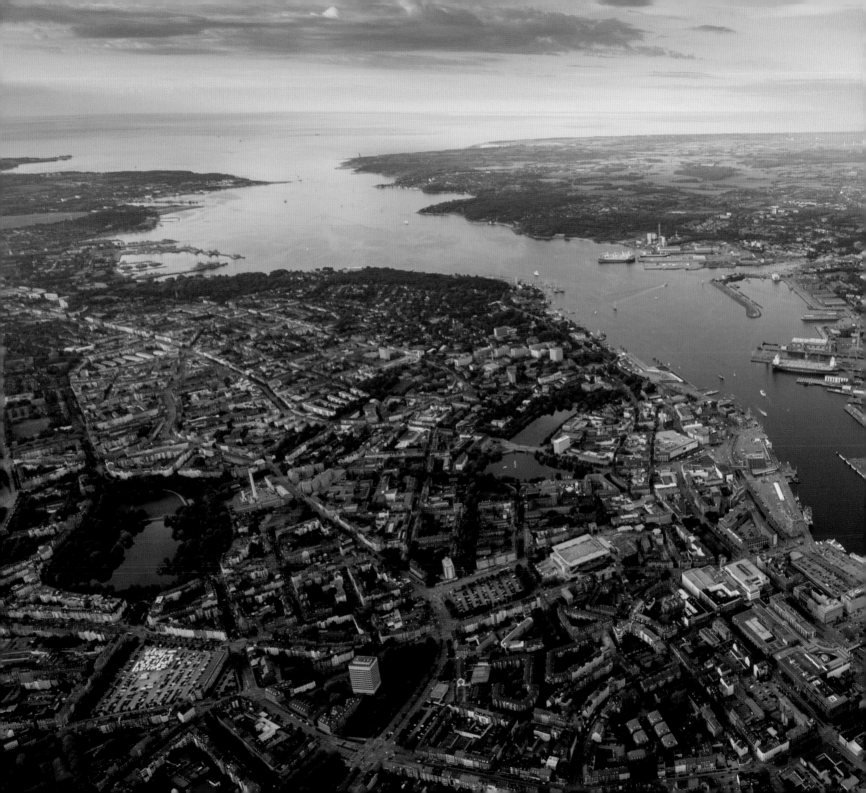

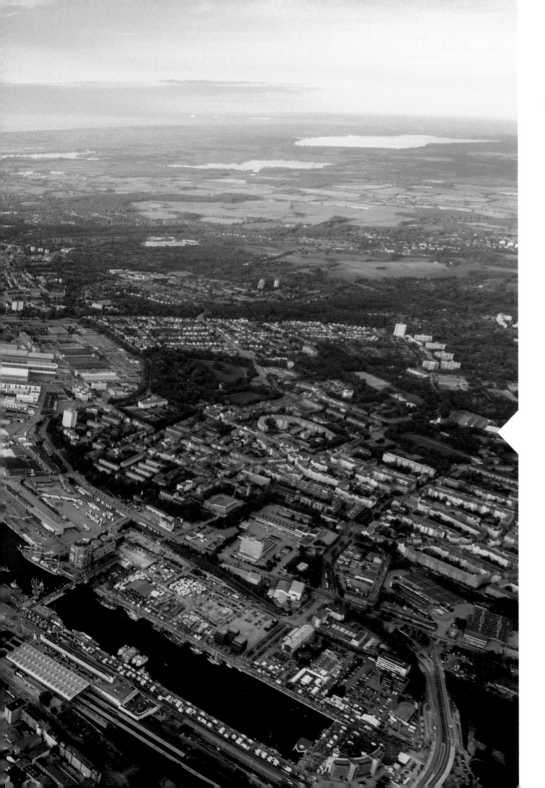

STADT, LAND, FÖRDE

CITY, LAND, FJORD

Gletscherbewegungen der letzten Eiszeit bescherten der LANDESHAUPTSTADT KIEL ihr unverwechselbares Gesicht: Rund 17 Kilometer ist die Kieler Förde, ein Meeresarm der Ostsee, lang. Strandbäder und Hafenpromenaden säumen die Uferseiten. Weiße Traumschiffe liegen mitten in der Stadt am Kai. Mit rund 120 Kreuzfahrtbesuchen und insgesamt 350.000 Passagieren ist Kiel der drittgrößte Reisewechselhafen Nordeuropas.

Glacier movement during the last Ice Age changed the face of the LANDESHAUPTSTADT KIEL. Kiel's fjord is about 17 kilometres long. It is an arm of the Baltic Sea, where beaches and harbour promenades line its banks. White cruise liners are moored right in the middle of the city. Kiel is Europe's third largest exchange port for cruises, with about 120 cruise liner visits and a total of 350,000 passengers.

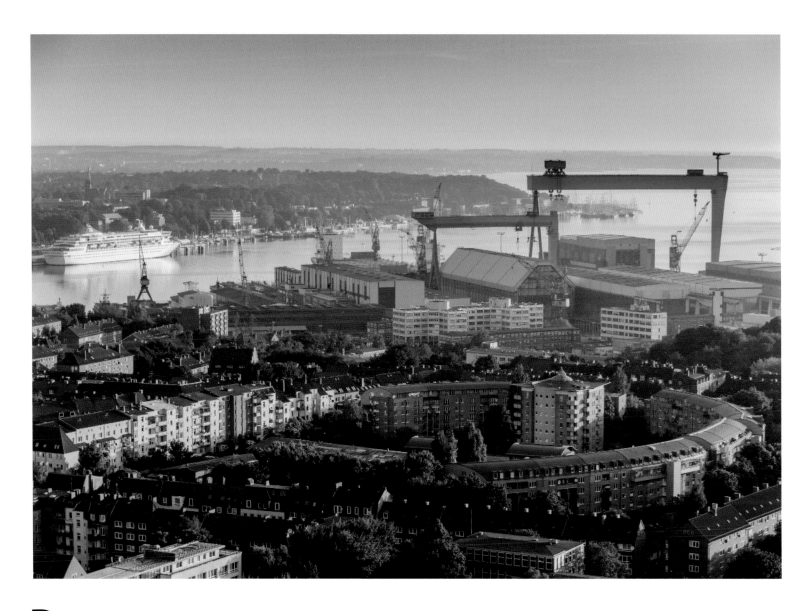

Die gewaltigen blauen Kräne am Ostufer der KIELER FÖRDE sind das markante Wahrzeichen der Stadt. Gegründet im Jahr 1838, entwickelte sich das Kieler Traditionsunternehmen als Howaldtswerke Deutsche Werft GmbH, kurz: HDW, zur größten Werft Deutschlands. Zwischenzeitlich umbenannt in German Naval Yards Kiel GmbH, werden auf dem riesigen Areal unter anderem hochtechnologische U-Boote mit nichtnuklearem Antrieb hergestellt.

The big blue construction cranes on the eastern bank of the KIELER FÖRDE are the city's trademarks. Founded in 1838, the heritage company evolved from the Howaldswerke Deutsche Werft GmbH, or »HDW,« to Germany's biggest shipyard. Now called the German Naval Yard Kiel GmbH for some time, this shipyard builds highly technical non-nuclear submarines and other marine vessels.

An der Spitze der Innenförde und im Zentrum der Stadt ist mit der KAI-CITY KIEL eine bunte Mischung aus Promenade und Traditionsseglern, Arbeiten und Wohnen entstanden.

The tip of the inner fjord in the city centre around QUAY-CITY-KIEL offers a colourful mix of promenade and traditional yachts, working and living quarters.

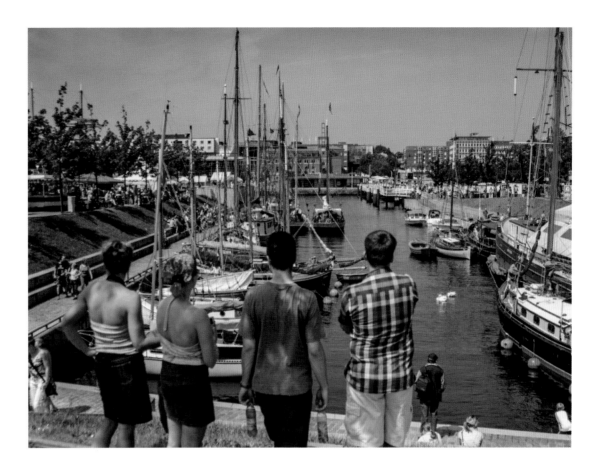

Das Aquarium am GEOMAR mit seinem viel besuchten Seehundbecken direkt an der Kiellinie gibt umfassend Einblick in die Tierwelt und Forschung der Ozeane.

GEOMAR Aquarium has a well-visited seal aquarium, located right at the edge of Kiel. It gives comprehensive insight into the fauna and the research of the oceans.

MARITIMES LEBEN

MARITIME LIFE

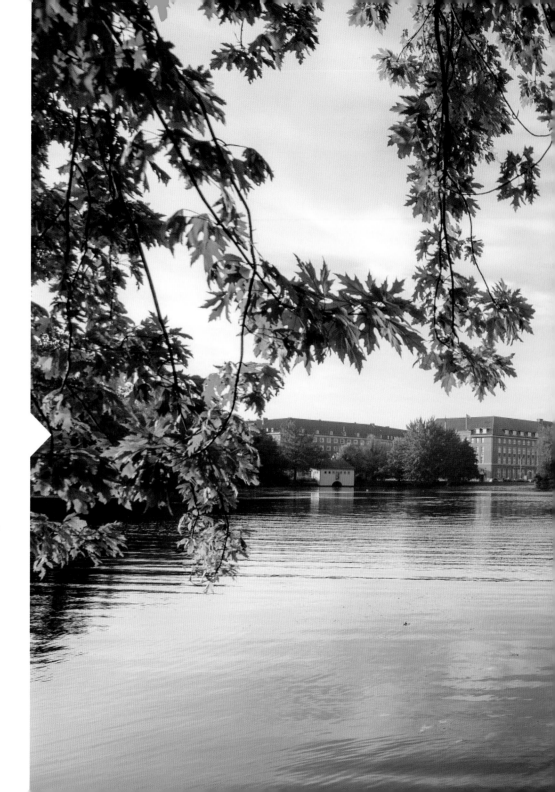

Einst war der KLEINE KIEL ein Meeresarm, der mit dem Bootshafen und der Kieler Förde verbunden war. Heute laden drei ineinander übergehende Parkanlagen mit alten, Schatten spendenden Bäumen zum Verweilen ein. Beliebt ist die Wasserinstallation »Changing Invisibility« des dänischen Künstlers Jeppe Hein, einmalig die Aussicht vom Rathausturm. Dem Campanile von San Marco in Venedig nachempfunden, ragt er 106 Meter in die Höhe.

Once an estuary, the KLEINE KIEL connected the marina and the Kieler Förde. Today, three parks are merged into one, and old trees offer plenty of shade for a rest. The water installation »Changing Invisibility« by Danish artist Jeppe Hein is popular, and the view from the town hall is spectacular. The building is based on the Campanile di San Marco in Venice and rises 106 metres into the sky.

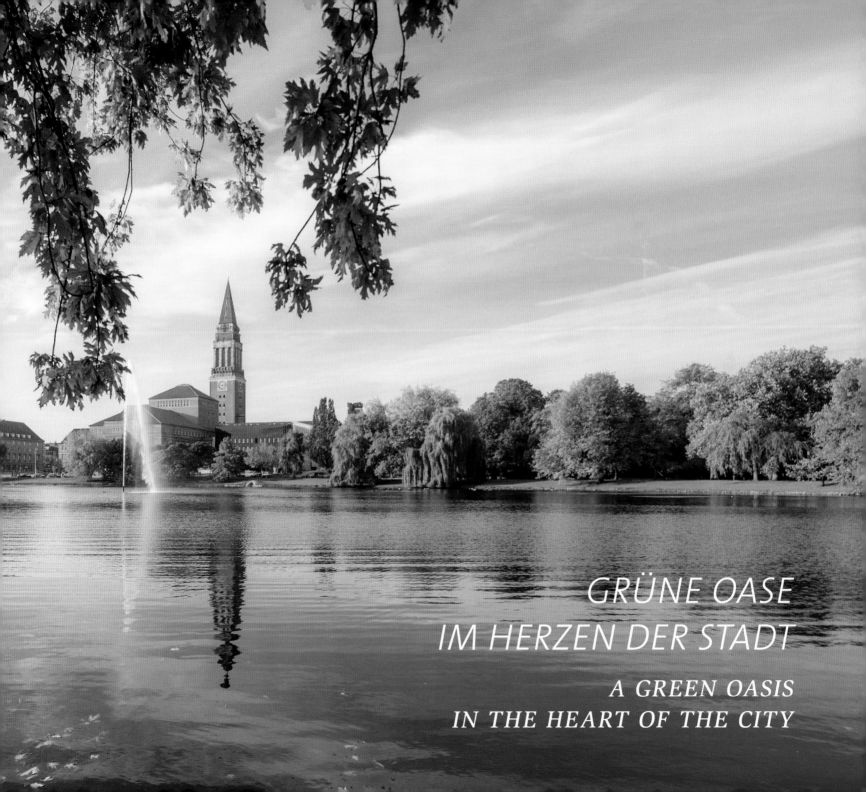

GRÜNE OASE
IM HERZEN DER STADT

A GREEN OASIS
IN THE HEART OF THE CITY

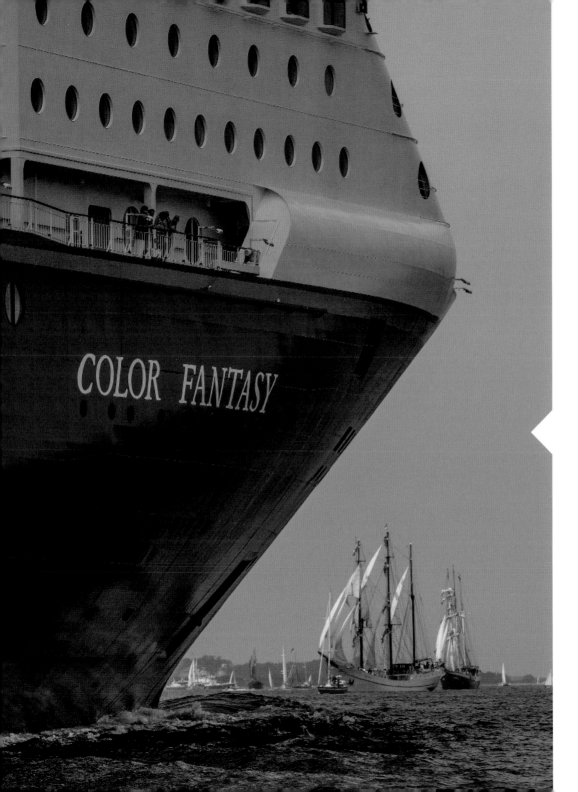

HEIMAT-HAFEN KIEL

HOMEPORT KIEL

Einmal am Tag wird es voll in der KIELER INNENFÖRDE: Am Nachmittag, wenn die »Color Fantasy« – oder das Schwesterschiff »Color Magic« – zu ihrer 20-stündigen Überfahrt nach Oslo aufbricht. Oder am Vormittag, wenn sie von ihrer Reise aus dem Norden zurückkehrt. Mit rund 220 Meter Länge sind sie die größten Fährschiffe der Welt; eindrucksvoll ist ihr Wendemanöver, um rückwärts am Norwegenkai festmachen zu können.

Once a day, KIEL'S INNER FJORD gets busy when Color Fantasy or her sister ship, Color Magic, depart for their 20-hour journey to Oslo. Every morning it's the same, when the ferry returns from the north. At 220 metres long, she is the biggest ferry in the world, and her transposition manoeuvre when mooring backwards along the Norway quay is impressive to watch.

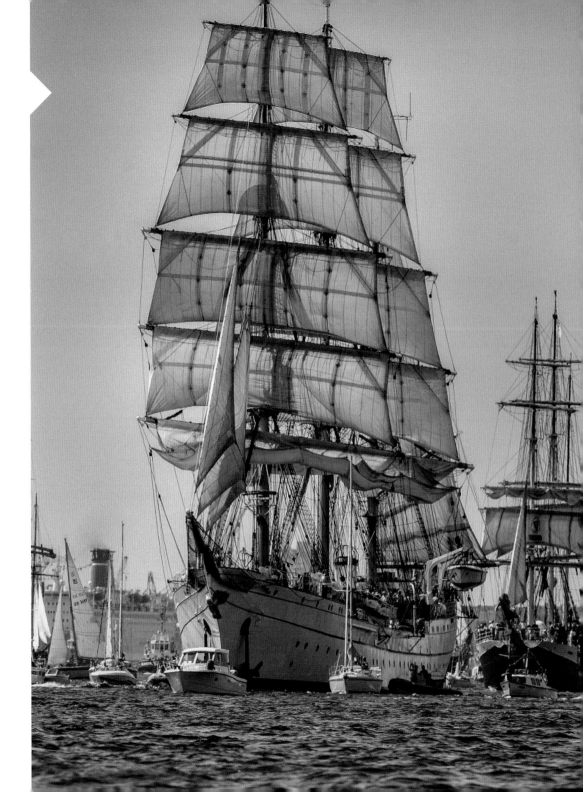

Das Segelschulschiff der Deutschen Marine lief im August 1958 in der Hamburger Werft Blohm & Voss vom Stapel. Benannt wurde der eindrucksvolle Dreimaster, der im KIELER TIRPITZHAFEN beheimatet ist, nach dem Finkenwerder Schriftsteller Johann Kinau. Mit seinen Seefahrergeschichten, veröffentlicht unter dem Pseudonym Gorch Fock, avancierte er zum Bestsellerautor des 20. Jahrhunderts.

Germany's naval training sailing ship was launched in August 1958 at the Blohm & Voss Shipyard in Hamburg. The impressive three-master, stationed at KIEL TIRPITZHAFEN, was named after the writer from Finkenwerder, Johann Kinau. He used the nom de plume Gorch Fock, and his seafaring stories made him a bestselling author of the 20th century.

Fakten: Gorch Fock

Länge	81,26 m
Anzahl der Segel	23
Segelfläche	rund 2.000 m²
Zurückgelegte Seemeilen	ca. 750.000
Baukosten	8,5 Mio. DM
Geschätzter Wert heute	50 Mio. Euro

Facts: Gorch Fock

Over all length	*81.26 m*
Number of sails	*23*
Combined sail size	*ca. 2,000 m²*
Nautical miles sailed	*ca. 750,000*
Cost of building	*8.5 Mio. DM*
Currently valued at	*50 Mio. Euro*

KIELER WOCHE

Das größte Volksfest Nordeuropas

KIEL WEEK

The biggest fair in Northern Europe

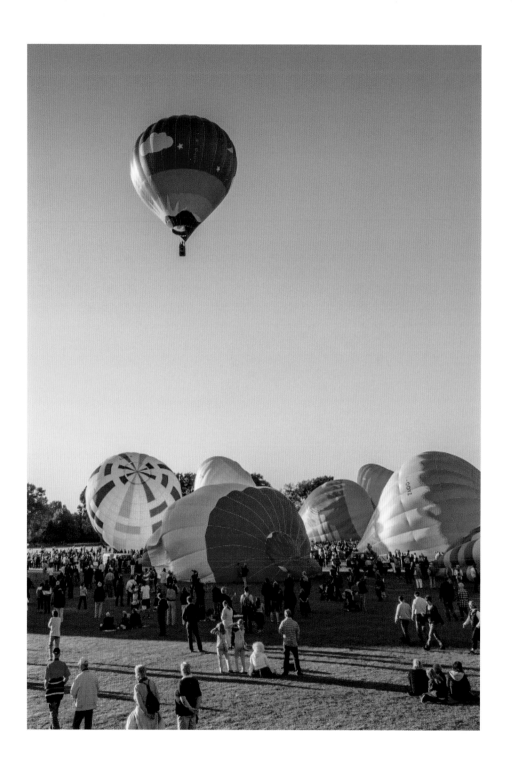

Fakten: Kieler Woche

Segelstarts	etwa 400
Segeldisziplinen	über 40
Teilnehmende Nationen	rund 70
Veranstaltungen	mehr als 2.000
Besucher	3,5 Mio.

Facts: Kiel Week

Starts in sailing events	ca. 400
Sailing disciplines	more than 40
Nations participating	ca. 70
Events	more than 2,000
Guests	3.5 Mio.

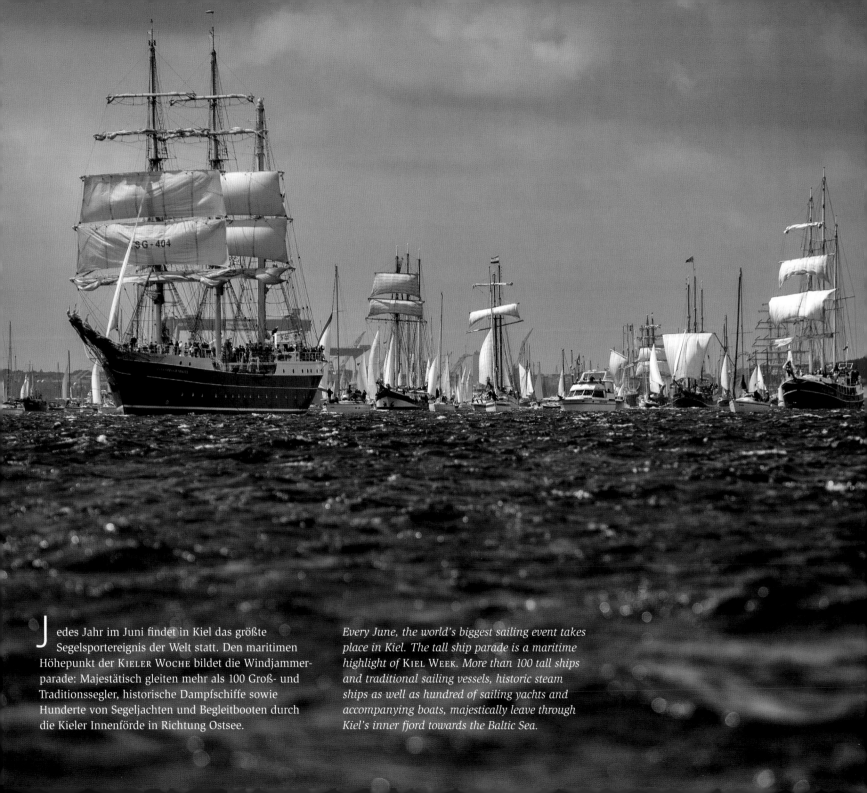

Jedes Jahr im Juni findet in Kiel das größte Segelsportereignis der Welt statt. Den maritimen Höhepunkt der KIELER WOCHE bildet die Windjammer-parade: Majestätisch gleiten mehr als 100 Groß- und Traditionssegler, historische Dampfschiffe sowie Hunderte von Segeljachten und Begleitbooten durch die Kieler Innenförde in Richtung Ostsee.

Every June, the world's biggest sailing event takes place in Kiel. The tall ship parade is a maritime highlight of KIEL WEEK. More than 100 tall ships and traditional sailing vessels, historic steam ships as well as hundred of sailing yachts and accompanying boats, majestically leave through Kiel's inner fjord towards the Baltic Sea.

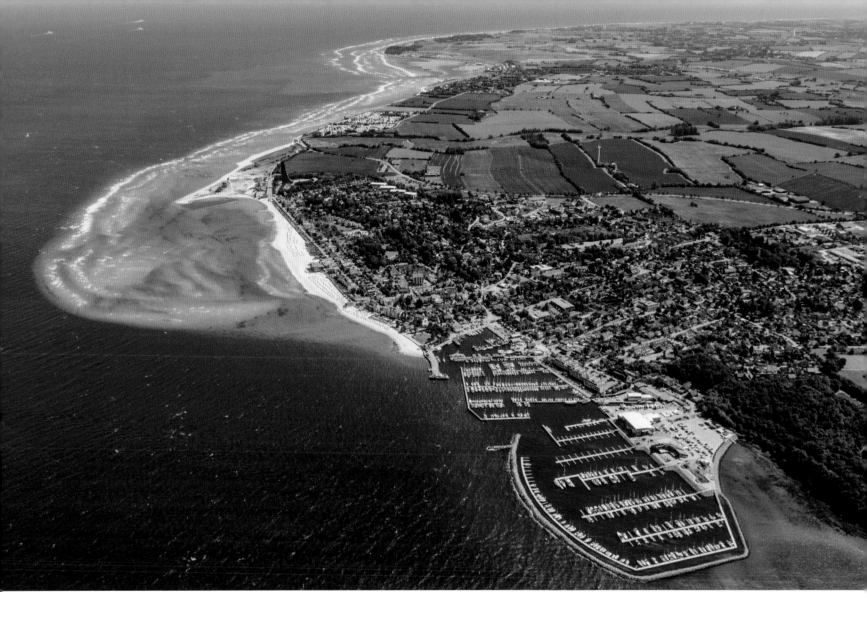

Das Ostseebad LABOE an der Kieler Außenförde ist mit seiner Mischung aus historischem Fischereihafen, moderner Marina und herrlichem Sandstrand bei Seglern und Sehleuten gleichermaßen beliebt. Vom 85 Meter hohen Marine-Ehrenmal eröffnet sich ein einmaliger Rundblick über Land und Meer. Das U-Boot U-995, heute ein historisch-technisches Museum, erinnert eindrücklich und abschreckend an die beklemmenden Bedingungen der Soldaten im Zweiten Weltkrieg.

The coastal resort LABOE, at Kiel's outer fjord, is a popular spot for sailors and visitors alike, offering a mix of fishing harbour, modern marina, and a fantastic beach. The view from the 85-metre-high marine memorial across the sea and land is phenomenal. Submarine U-995 is a technical museum offering an impressive inside view into the appalling and constricted living conditions of marines during the Second World War.

Am kilometerlangen feinsandigen Strand von SCHÖNBERG liegen Kalifornien und Brasilien nur einen Katzensprung voneinander entfernt. Der Ursprung der exotischen Namen liegt bereits über 300 Jahre zurück: Ein Fischer entdeckte am Strand eine angetriebene Schiffsplanke, in die der Name »California« geritzt war, und nagelte sie an seine Haustür. Neidvoll erblickte sein Nachbar das Schild und pinselte kurzerhand »Brasilien« auf ein altes Stück Holz über seinem Eingang.

Kalifornien and Brasilien are only a stone's throw apart, along a beach of SCHÖNBERG, several kilometres long. In case you're puzzled: The names originated a few hundred years ago. A fisherman found a piece of driftwood with the word »California« carved into it. He put it over his entrance door; however, an envious neighbour then painted the word »Brasilien« on an old piece of wood and put that over his door as well.

HAFENFLAIR UND OSTSEEFRISCHE

HARBOUR FLAIR AND BALTIC BREEZE

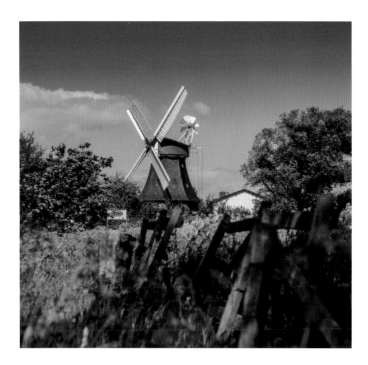

Im Jahr 1872 auf einem Hügel errichtet, schmückt die denkmalgeschützte Mühle in KROKAU das Landschaftsbild der PROBSTEI. Von Pfingstmontag bis Oktober findet jeden Sonntag eine fachkundige Führung durch den restaurierten, noch mahlgängigen Kellerholländer statt.

The state-heritage-listed mill in KROKAU was built on a hill in 1872 and has been domiating the landscape of the PROBSTEI ever since. Comprehensive tours are offered every Sunday, from Whitsun Monday until October, and show the still-functioning and fully restored Basement Dutchman.

Lange Zeit galt die PROBSTEI als Kornkammer der gesamten Region – ein ländliches Idyll mit weiten Getreide- und Rapsfeldern, kleinen Dörfern, Hofläden und Bauerncafés ist es bis heute geblieben. Reizvolle Rad- und Wanderwege durch die vielseitige Ufervegetation umrunden die Seen. Ein faszinierendes Naturschauspiel lässt sich im Herbst am DOBERSDORFER SEE beobachten, wenn Tausende von Staren ihr spektakuläres Flugmanöver zeigen.

The PROBSTEI area was considered the granary for the whole region, and vast wheat and rapeseed fields, small villages, farm stores, and cafes still make this area a countryside idyll. You can ride or walk around the lake and appreciate the diverse vegetation growing on the banks. In autumn, you can watch thousands of starlings perform spectacular flight manoeuvres around the DOBERSDORF LAKE.

KLARE SEEN, WEITES LAND

CLEAR LAKES, VAST LANDS

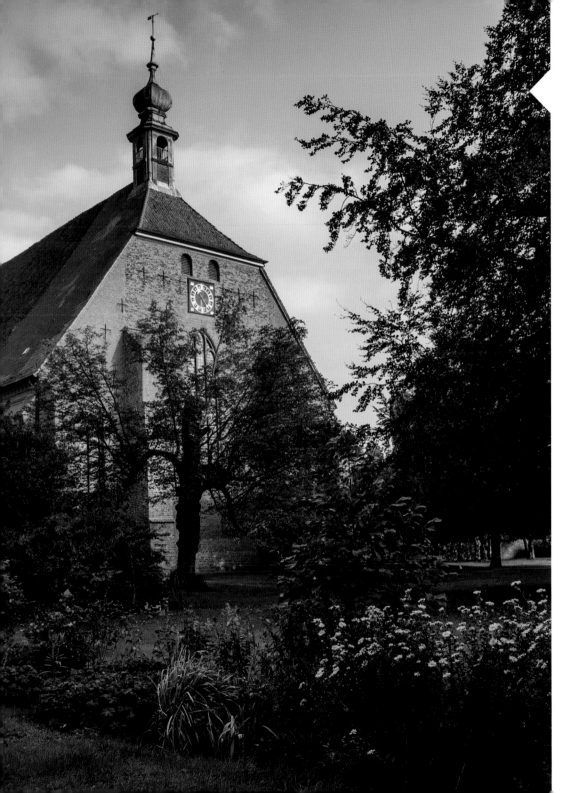

Durch ein Torhaus und über jahrhundertealtes Kopfsteinpflaster führt der Weg zum ehemaligen Benediktinerinnenkloster in PREETZ: ein Refugium der Stille. Gegründet im Jahr 1211, war es im Mittelalter mit rund 70 Nonnen das bedeutendste Frauenkloster Schleswig-Holsteins. Nach der Reformation wurde es – und wird es bis heute – als adliges Damenstift weitergeführt. Ausgesprochen sehenswert ist die dreischiffige gotische Klosterkirche, die zu den schönsten Kulturdenkmälern des Nordens zählt.

Walk through the gatehouse, across centuries-old cobblestone streets, and you will reach the former Benedictine convent in PREETZ – a place of silence. Founded in 1211, it used to be one of the most significant women's abbeys in Schleswig-Holstein, housing more than 70 nuns. After the Reformation took place, it served as a noble ladies' serminary, which it still is today. A visit to the three-nave Gothic church of the abbey is well worth your time. It is one of the most beautiful cultural memorials in Northern Germany.

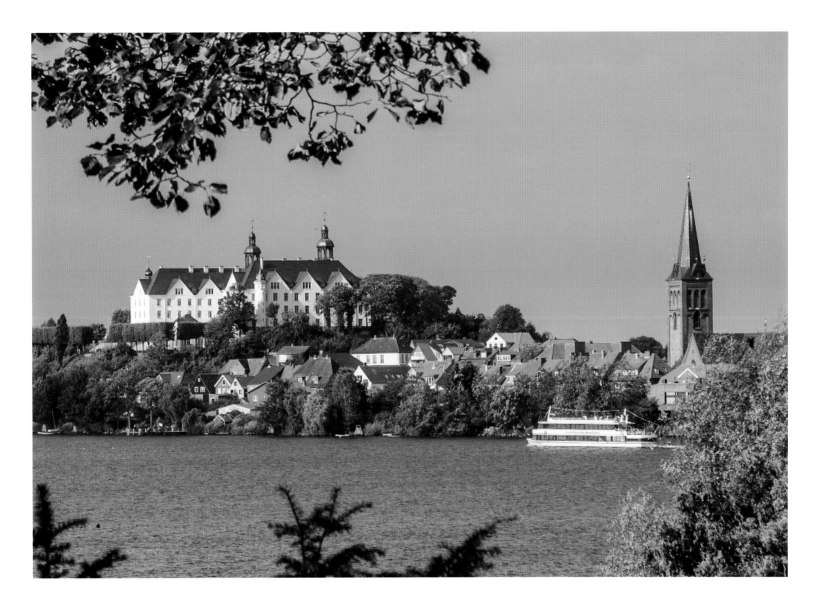

Eines der größten Schlösser Schleswig-Holsteins thront würdevoll und von Weitem sichtbar am größten See des Landes, dem Plöner See. Es ist zudem das einzige erhaltene Schloss, das hierzulande in Höhenlage errichtet wurde. Während des Dreißigjährigen Krieges als herzogliche Residenz erbaut, fungierte das PLÖNER SCHLOSS später als Erziehungsanstalt und Internat. Seit 2002 ist der prunkvolle Renaissance-Neubau Sitz der Fielmann-Akademie und im Rahmen einer Führung zu besichtigen.

One of the biggest castles in Schleswig Holsteins rises prominently and gracefully from the largest lake in the state, the Plöner See. It is also the only remaining castle built on elevated ground. The castle in PLÖN was erected during the Thirty Years' War and was used as a reformatory and boarding school. The opulent building has been the home of the Fielmann Academy since 2002; however, it is open for visitors on guided tours.

Der Naturpark Holsteinische Schweiz ist mit 750 Quadratkilometern der größte Schleswig-Holsteins. Über 200 Seen wechseln sich mit sanften Hügeln, Feldern und kleinen Waldgebieten ab. Nirgends in Norddeutschland ist der Seeadler so häufig anzutreffen wie hier. Mit seiner beachtlichen Spannweite von bis zu zweieinhalb Metern ist der König der Lüfte der größte Greifvogel Mitteleuropas.

With 750 square kilometres, the Nature Park of Schleswig-Holstein is the biggest natural park in the state. More than 200 lakes intersperse the scenery of soft hills, fields and small forests. You won't find more white-tailed eagles anywhere else in Schleswig-Holstein. The king of the skies, whose impressive wingspread can reach up to two-and-a-half metres, is the biggest bird-of-prey in central Europe.

Das malerische Schloss Eutin, komplett von einem Wassergraben umgeben, war ursprünglich eine mittelalterliche Bischofsburg. Im 18. Jahrhundert wurde sie zum repräsentativen Wohnschloss der Großherzöge von Oldenburg umgebaut und wird heute museal und kulturell genutzt. Ebenfalls für Besucher zugänglich ist der stilvolle Englische Landschaftsgarten, der zu den schönsten Norddeutschlands zählt.

The picturesque Eutin castle, surrounded by a moat, used to be a bishop's castle. It was converted into a representative residential castle for Oldenburg's grand duke during the 18th century. Today, it is used as a museum and cultural centre. Visitors can also access the elegant English Garden, one of the most beautiful in Northern Germany.

KULTUR VON IHRER SCHÖNSTEN SEITE

CULTURE'S MOST BEAUTIFUL FACE

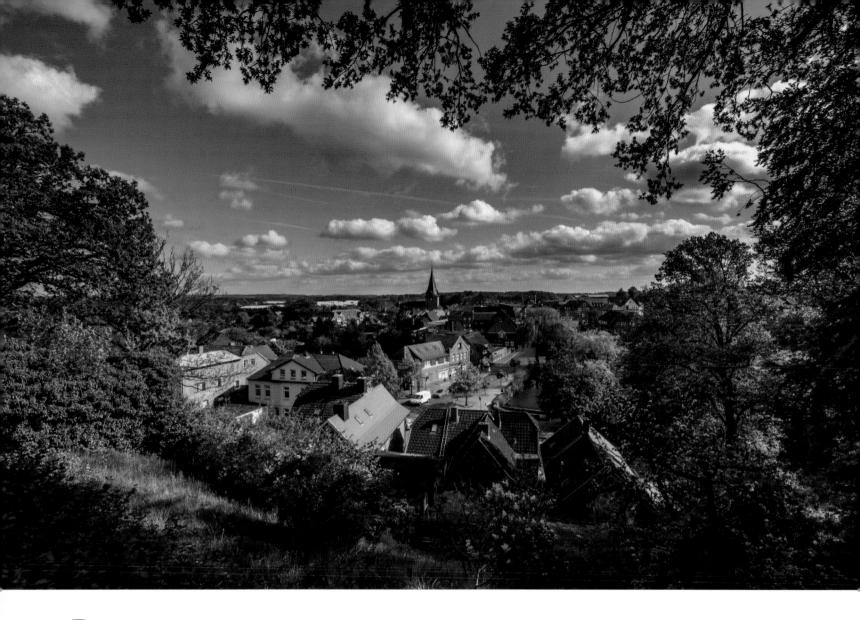

Das kleine Städtchen LÜTJENBURG galt einst als Fachwerkidyll; mehrere Großbrände vernichteten die hübschen Häuser jedoch fast gänzlich. Eines der wenigen verschont gebliebenen ist auf dem historischen Marktplatz zu bewundern: Das traditionelle Färberhaus ist mit über 400 Jahren das älteste Wohnhaus des Ortes. Bei klarer Sicht lädt der Bismarckturm zu einem fantastischen Ausblick über die Hohwachter Bucht bis zu den dänischen Inseln ein.

Before several major fires destroyed the pretty houses of LÜTJENBURG, the town was considered a timber-framed-house idyll. One house that was spared the flames can still be visited on the market square. At 400 years old, the traditional dyer's house is one of the oldest buildings in town. During fair weather, the Bismarckturm offers a view across the Hohwachter Bucht all the way to the Danish Islands.

SPUREN
VERGANGENER
ZEITEN

SIGNS
OF THE PAST

Der imposante Oldenburger Wall, der vor mehr als 1.000 Jahren den slawischen Fürstensitz Starigrad – »Alte Burg« – umschloss, ist eines der herausragendsten archäologischen Bodendenkmale Schleswig-Holsteins. Spannend und kurzweilig gibt das Wallmuseum in OLDENBURG auf dem Gelände der damaligen Siedlungsstätte Auskunft über die Zeit der Slawen und informiert anschaulich über Leben und Alltag im frühen Mittelalter.

An impressive embankment in Oldenburg circled the Slavic princely residence Starigrad or »Alte Burg« (old castle) 1,000 years ago. Today, it is one of the most outstanding archaeological ground memorials in Schleswig-Holstein. The »Wallmuseum« in OLDENBURG, located on the old site of the Slavic settlement, provides interesting information about the times of the early settlers and their life during the Early Middle Ages.

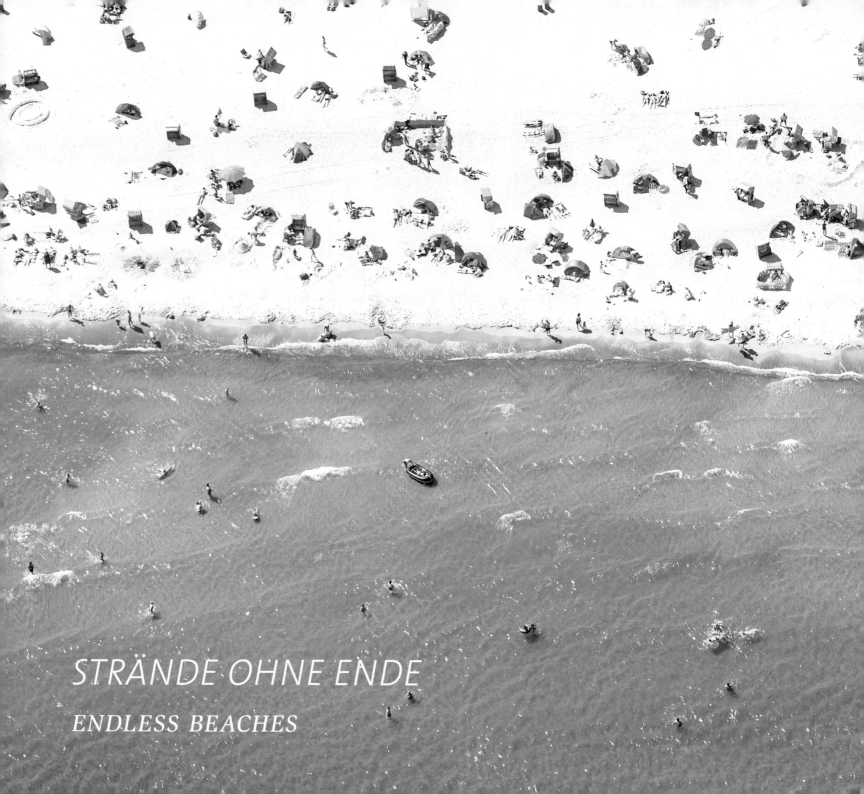

STRÄNDE OHNE ENDE

ENDLESS BEACHES

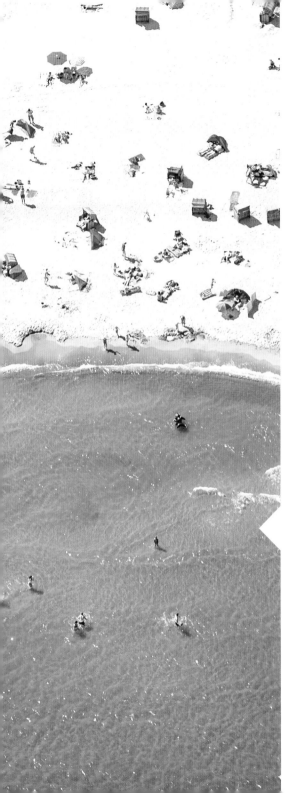

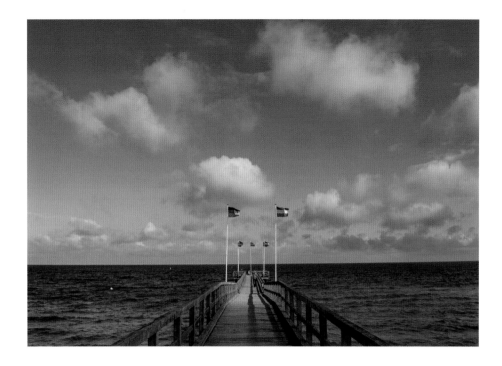

M it Seebrücke, Strandkörben und vielfältigen Freizeitangeboten ist der WEISSENHÄUSER STRAND in der HOHWACHTER BUCHT besonders für Familien ein attraktives Ausflugsziel. Bei starkem Wind aus Nordwest entpuppt sich der quirlige Urlaubsort zugleich als Surfmekka: In bis zu drei Meter hohen Wellen zeigen zahlreiche Wind- und Kitesurfer waghalsig ihr Können.

WEISSENHÄUSER STRAND at the HOHWACHTER BUCHT is a popular family holiday destination. It has a pier, roofed wicker beach chairs, and many other holiday attractions. The town turns into a surf mecca as soon as a strong north-westerly breeze comes through: Windsurfers and kite surfers alike show their daring skills in the up-to-three-metre surf.

R und 185 Kilometer ist die abwechslungsreiche Küsten-linie OSTHOLSTEINS lang. Von verträumten Naturstränden bis zu schicken Seebädern findet hier jeder seinen persönlichen Lieb-lingsplatz an der Sonne.

The diverse coastline of OSTHOLSTEIN is 185 kilometres long. Everyone can find a favourite sunny spot, ranging from dreamy natural beaches to elegant seaside resorts.

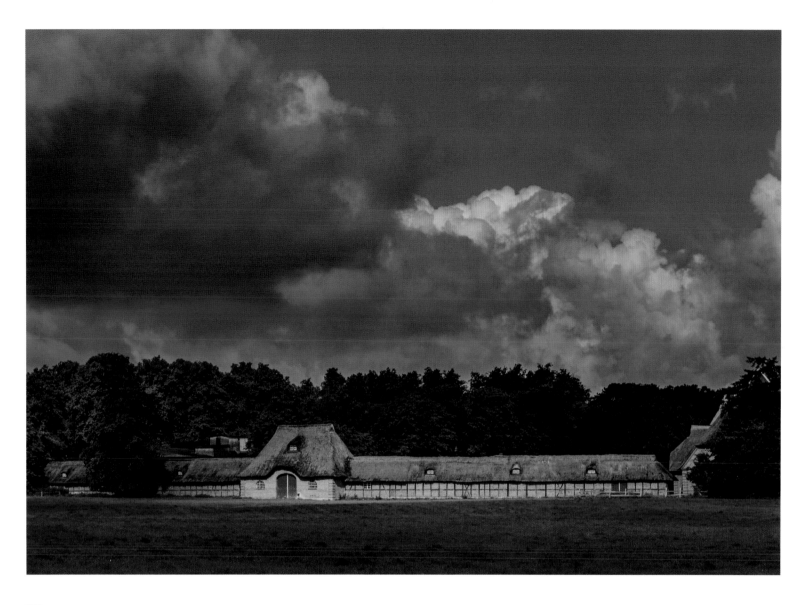

Etwa 300 Adelssitze gaben der Region rund um die Hohwachter Bucht einst den Beinamen »Grafenwinkel«. Noch heute gehören die prächtigen Schlösser, stolzen Herrenhäuser und weitläufigen Gutshöfe zu den kulturellen Sehenswürdigkeiten Schleswig-Holsteins. Viele der ehemals adligen Anwesen sind noch heute im Familienbesitz; manche – wie das GUT EHLERSTORF in der Nähe von Oldenburg – aus diesem Grund der Öffentlichkeit nicht zugänglich.

The region around the Hohwachter Bucht was once called »Earl's Corner« because of the more than 300 noble estates in the area. Elegant castles, proud noble manors, and vast farmhouse estates are still part of Schleswig-Holstein's cultural sights. Some of the former noble houses, like GUT EHLERSTORF *near Oldenburg, are still family-owned today, and thus are not open to the public.*

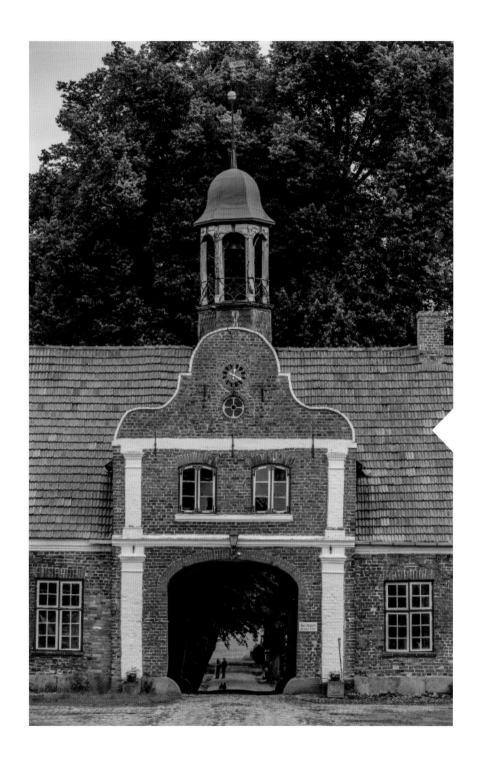

Das Gut Seegalendorf zwischen Oldenburg und Heiligenhafen zählt mit seinem alten Torhaus zu den wenigen noch komplett erhaltenen adligen Gutsanlagen Ostholsteins. Einzig das ursprüngliche Hauptgebäude im Zentrum des weitläufigen Hofgeländes wurde 1839 durch einen schlichten spätklassizistischen Neubau ersetzt. Neben einer Shetlandpony-Zucht betreibt das Gut heute einen kinderfreundlichen Reiterhof mit Ferienunterkünften.

The Seegalendorf farm between Oldenburg and Heiligenhafen and its old gatehouse count as one of the few noble farms in Ostholstein that are well-preserved. The main building is the only one on the vast area that was replaced with a simple building in late classical style in 1839. These days, the farm breeds Shetland ponies and runs a family-friendly stable offering holiday accommodations.

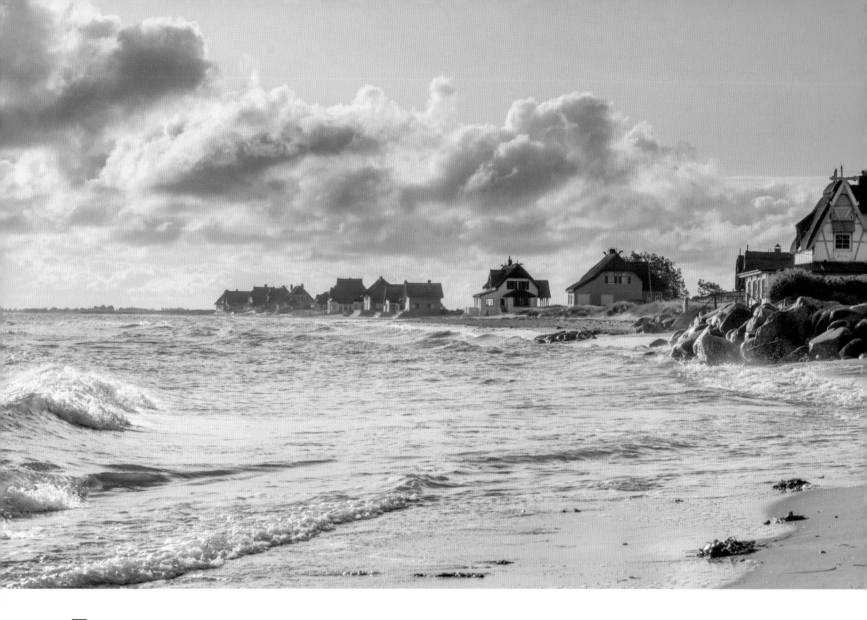

Feiner Ostseestrand auf der einen, wild bewachsene Salzwiesen auf der anderen Seite: GRASWARDER an der Spitze HEILIGENHAFENS ist ein einzigartiges Naturschutzparadies. Denkmalgeschützte reetgedeckte Strandvillen stehen unmittelbar am Flutsaum. Am Ende der Häuserreihe eröffnet sich von dem zwölf Meter hohen Aussichtsturm, mit dem der Stararchitekt Meinhard von Gerkan 2008 den Internationalen Architekturpreis gewann, ein traumhafter Rundblick über die Halbinsel.

Soft Baltic Sea sand on one side and natural salt meadows on the other make GRASWARDER, at the tip of HEILIGENHAFEN, a unique protected natural paradise. Preserved thatched beach villas stand right on the waterline. The architect Meinhard von Gerkan, who designed the twelve-metre-high lookout, received an International Architecture Award for the tower offering a fantastic view across the peninsula.

Exklusive Marina und lebendiger Fischereihafen, historischer Ortskern und außergewöhnliche Seebrücke: Das moderne Ferienzentrum HEILIGEN- HAFEN verspricht vielseitige Urlaubserlebnisse am schönen Ostseestrand. Veranstaltungshöhepunkt sind die Hafenfesttage im Sommer, wenn alte Traditions- schiffe im Hafen zu bestaunen sind.

HEILIGENHAFEN delivers a varied beach holiday experience, ranging from an exclusive marina and a lively fishing harbour, to an historic town centre and an extraordinary sea bridge. The harbour festivities in summer are a calendar highlight, and everyone can admire the traditional ships moored in the marina.

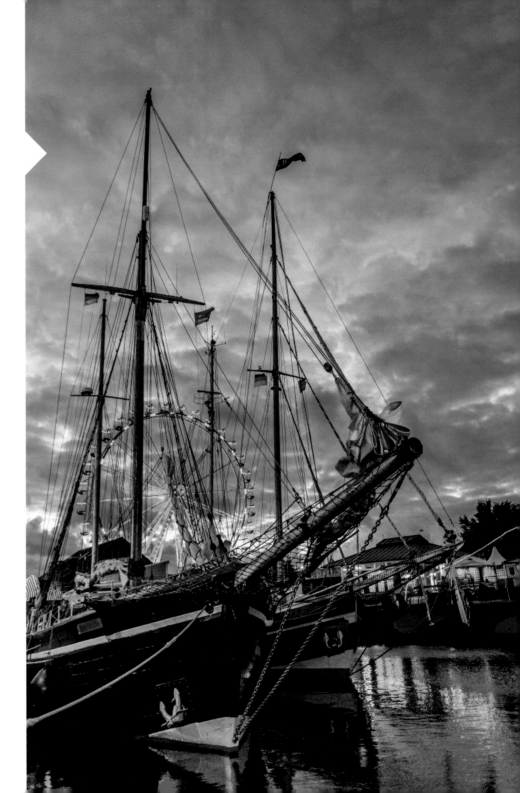

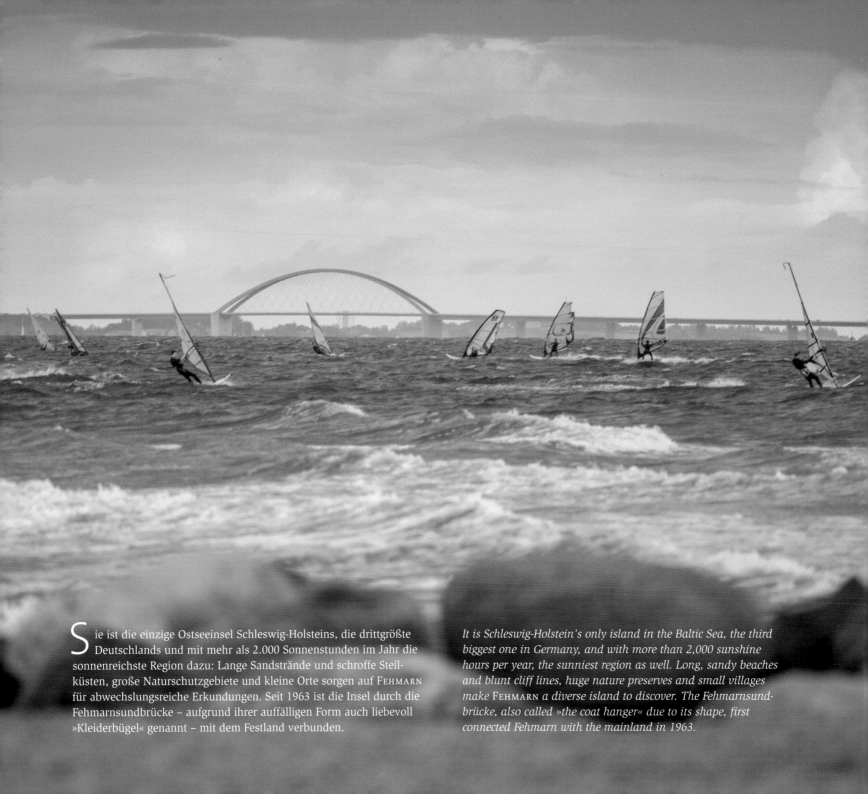

Sie ist die einzige Ostseeinsel Schleswig-Holsteins, die drittgrößte Deutschlands und mit mehr als 2.000 Sonnenstunden im Jahr die sonnenreichste Region dazu: Lange Sandstrände und schroffe Steilküsten, große Naturschutzgebiete und kleine Orte sorgen auf FEHMARN für abwechslungsreiche Erkundungen. Seit 1963 ist die Insel durch die Fehmarnsundbrücke – aufgrund ihrer auffälligen Form auch liebevoll »Kleiderbügel« genannt – mit dem Festland verbunden.

It is Schleswig-Holstein's only island in the Baltic Sea, the third biggest one in Germany, and with more than 2,000 sunshine hours per year, the sunniest region as well. Long, sandy beaches and blunt cliff lines, huge nature preserves and small villages make FEHMARN a diverse island to discover. The Fehmarnsundbrücke, also called »the coat hanger« due to its shape, first connected Fehmarn with the mainland in 1963.

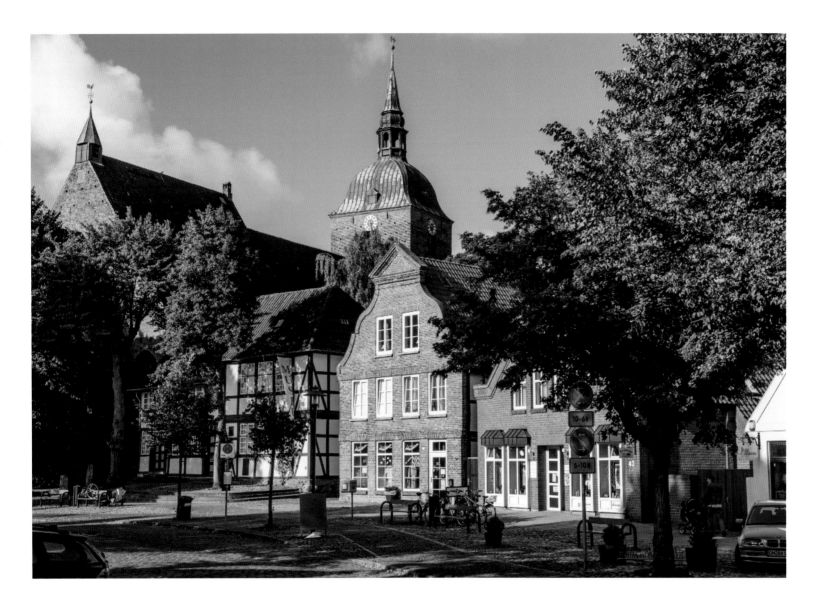

Hauptort und kulturelles Zentrum FEHMARNS ist BURG mit verträumten Gassen und kleinen Geschäften. Passend zur engen Verbundenheit der Insel mit dem Meer ist die gotische Backsteinkirche St. Nikolai dem Schutzpatron der Seefahrer, dem Heiligen Nikolaus, gewidmet. Ein Besuchermagnet ist die faszinierende tropische Unterwasserwelt im Meereszentrum Fehmarn – mit vier Millionen Liter Meerwasser eines der größten Aquarien Europas.

BURG is the main town and cultural centre of FEHMARN, consisting of sleepy alleyways and small shops. The island's close connection with the sea can be understood when viewing at the Gothic brick church St. Nikolai, fittingly dedicated to the patron saint of sailors – St. Nicholas. Fehmarn's aquarium is a visitor's magnet, showcasing a fascinating tropical underwater world. Its water capacity of four million litres makes it one of the biggest aquariums in Europe.

Abgeschieden und in ruhiger Natur, rund 20 Kilometer von OLDENBURG entfernt, liegt eines der ältesten Güter Ostholsteins: 1932 erwarb Alfred Töpfer das GUT SIGGEN, das heute intensiv für Aktivitäten der gleichnamigen Stiftung und als Seminarzentrum genutzt wird. Mit jährlich wechselndem Thema und Künstlern aus ganz Europa bereichert der Siggener Kultursommer den regionalen Veranstaltungskalender.

Far off the beaten track amidst the calm of nature, about 20 kilometres from OLDENBURG, lies one of the oldest farm estates in Ostholstein. Alfred Töpfer acquired GUT SIGGEN in 1932. Today, it is used intensively for the activities of the Siggen Foundation, and also serves as a conference centre. The annual Siggener Kultursommer is an highlight on the event calendar, with different topics and artists from all over Europe on the agenda.

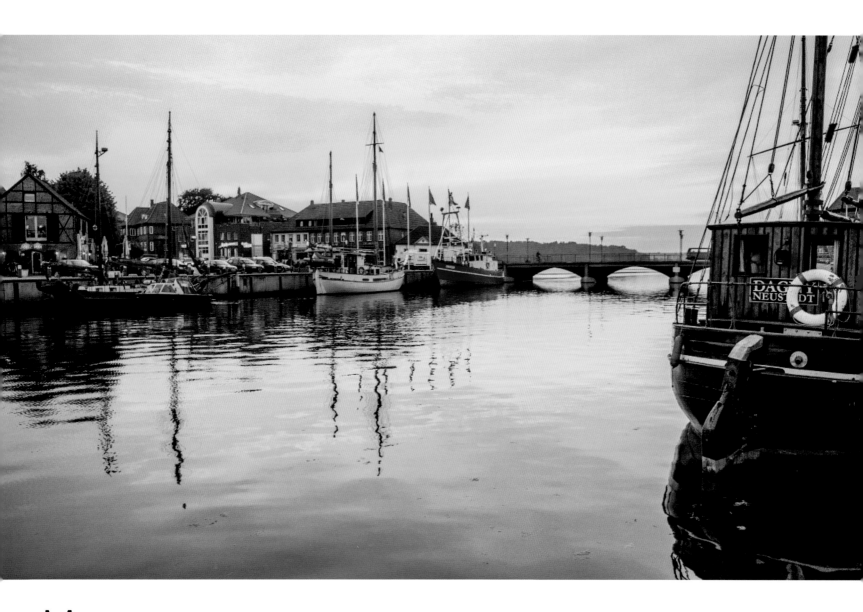

Mit mehr als 1.500 Liegeplätzen ist Neustadt eines der
renommiertesten Segelzentren Schleswig-Holsteins. Historische
Segelschiffe, Fischkutter und moderne Jachten liegen dicht an dicht im
fjordähnlichen Hafen; auch die »Albatross II«, aus der ZDF-Serie »Küsten-
wache« bekannt, ist hier beheimatet. Unweit des charmanten Hafen-
städtchens laden die beiden Ostseebäder Pelzerhaken und Rettin zu
Wassersport und Strandvergnügen ein.

*Neustadt is one of the most renowned sailing centres in Schleswig-
Holstein, thanks to its marina boasting more than 1,500 berths.
Historic sailing boats, fishing boats and modern yachts are berthed
next to each other in the fjord-like marina. You can even find
»Albatross II« from the ZDF television show »Küstenwache« here.
Not far from this charming harbour town are Pelzerhagen and
Rettin, two towns famous for their water sport and beachside fun.*

OSTSEEBÄDERTRADITION
BALTIC RESORT TRADITION

Durch die Anerkennung als Ostseeheilbad im Jahr 1951 gelang der Gemeinde TIMMENDORFER STRAND der Aufstieg zu einem der gefragtesten Ostseestrände Schleswig-Holsteins. Aufgrund der Nähe zu Lübeck und Hamburg ein attraktives Ausflugsziel der Großstädter, tummeln sich zahlreiche Gäste am feinsandigen Strand und bummeln durch die noblen Geschäfte. Seit mehr als 20 Jahren ist der Timmendorfer Strand Austragungsort der deutschen Meisterschaft im Beachvolleyball.

When the TIMMENDORFER STRAND community was recognised as a coastal resort in 1951, it soon became one of the most sought-out beaches on the Baltic coast in Schleswig-Holstein. Its proximity to Lübeck and Hamburg makes it an attractive excursion for city slickers, and many visitors roam the beaches and stroll along the line of elegant shops. Timmendorfer Strand has been the venue for the German Beach Volleyball championship for more than 20 years.

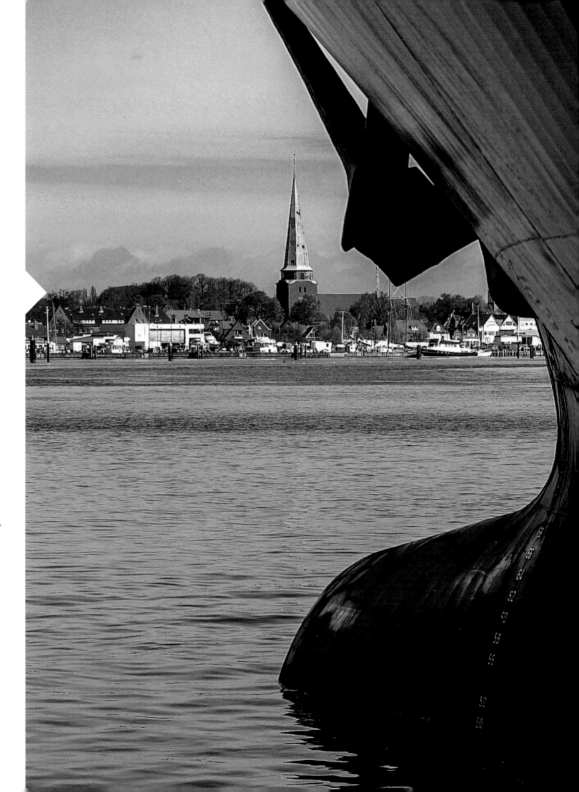

Direkt an der Münde von der Trave in die Ostsee lockt Lübecks »schönste Tochter« mit dezent hanseatischem Schick. Das kleine Fischerdorf TRAVEMÜNDE, gegründet im Jahr 1187, entwickelte sich im 19. Jahrhundert zum mondänsten Seebad Deutschlands, das Casino zum Treffpunkt internationaler Prominenz. Auch Franz Kafka ließ seine Gedanken am Strand schweifen – zum Entsetzen der feinen Gesellschaft ungeziemend mit nackten Füßen im Sand.

On the mouth of the Trave River on the Baltic Sea, Lübeck's »prettiest daughter« charms with her discrete Hanseatic glamour. The small fishing village TRAVEMÜNDE was founded in 1187 and evolved into a sophisticated German coastal resort, its casino a meeting grounds for international celebrities. Even Franz Kafka let his mind wander on the beach and shocked the noble high society by going for a walk in the sand barefoot.

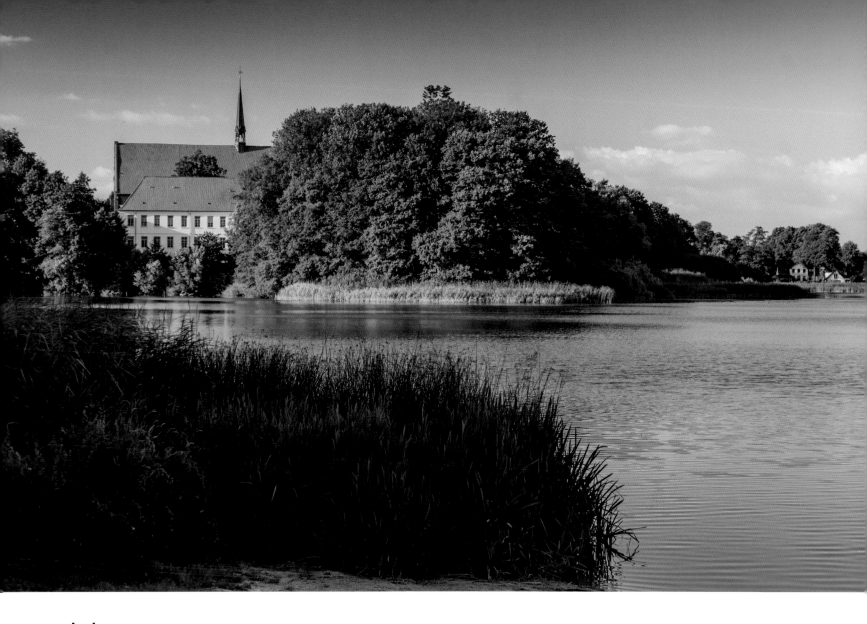

Um 1330 siedelten die Augustiner Chorherren mit ihrem 1127 in Neumünster gegründeten Stift nach BORDESHOLM über. »Am Ufer der Insel« im Bordesholmer See fanden die Mönche endlich die beschauliche Ruhe, die sie für ihr Kloster suchten. Das Herzstück des Geländes, die gotische Klosterkirche, liegt eingebettet in eine schöne Parkanlage und erinnert als letztes noch erhaltenes Bauwerk an vergangene Zeiten.

In 1330, Augustinian canons relocated their Neumünster abbey, founded in 1127, to BORDESHOLM. »On the banks of the island«, in the middle of the lake in Bordesholm, the monks finally found the peace they sought. The heart of the monastery's compound is a Gothic church, surrounded by a beautiful park. The last remaining building of the monastery recalls the past.

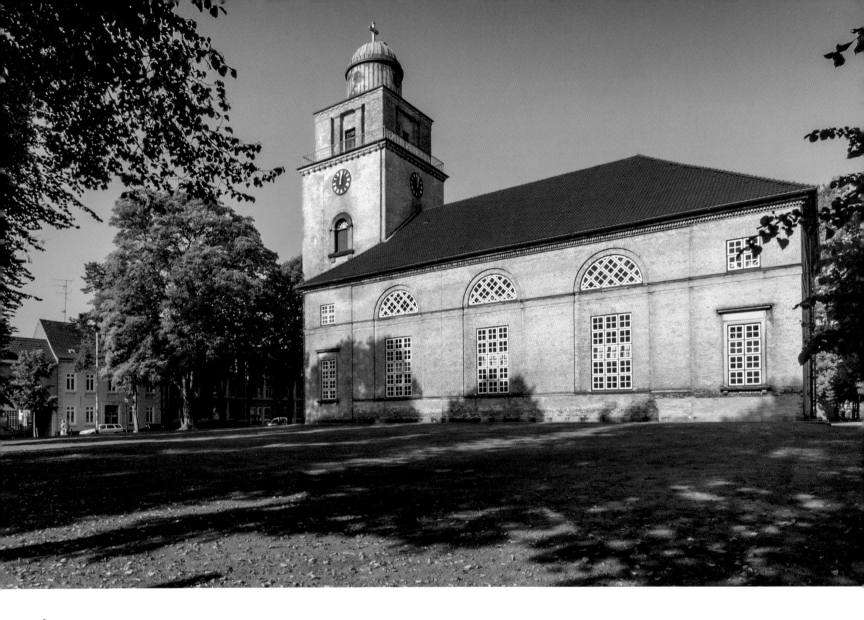

m Jahr 1127 vom Bremer Erzbischof gesandt, gründete der Missionar
Vicelin an der Schwale ein Augustinerstift und gab ihm den Namen
»Novum Monasterium«. Aufgrund seiner Lage mitten im Land und als
Verkehrsknotenpunkt alter Handelswege gewann NEUMÜNSTER schnell
an Bedeutung und entwickelte sich zum Zentrum der Tuch- und Leder-
industrie. Die eindrucksvolle Vicelinkirche zählt zu den bedeutendsten
klassizistischen Kirchenbauwerken Schleswig-Holsteins.

*Sent out by Bremen's Archbishop in 1127, the missionary Vicelin
founded an Augustinian monastery at the Schwale River and
named it »Novum Monasterium.« Due to its location in the middle
of the country, NEUMÜNSTER became a traffic and trade junction.
The city quickly gained importance and became a centre for the
fabric and leather industry. The Vicelin church is one of the most
important Classical church buildings in Schleswig-Holstein.*

V on Wiesen, Wäldern und Auen umgeben, wurde ITZEHOE im
Mittelalter inmitten einer Schleife der schiffbaren Stör erbaut.
Sturmfluten und Überschwemmungen stellten die Stadt jedoch
jahrhundertelang vor große Herausforderungen. 1974 wurde der
natürliche Flusslauf zugeschüttet, der Altstadtkern verlor damit sein
attraktives Gesicht. Ambitioniert plant der Verein »Störauf« nun-
mehr, die ehemalige Störschleife wiederzubeleben.

Surrounded by grassland, forests, and meadows, ITZEHOE
was built during the Middle Ages into a loop of the navigable
Stör River. Storm tides and floods challenged the city many
times throughout the centuries. The natural course of the
river was closed in 1974, and the old town lost its attractive
aspect. The »Störauf« society now ambitiously plans the
reopening of the former Stör loop.

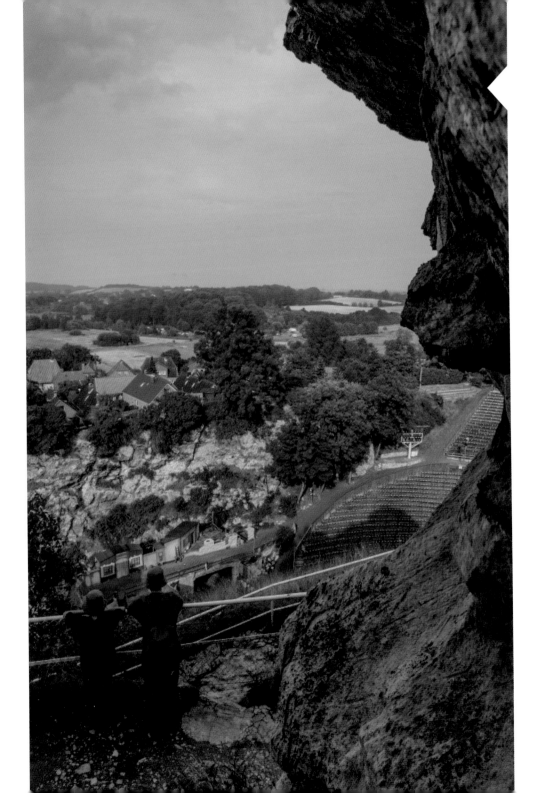

Die Namen Karl May und Bad Segeberg
gehören untrennbar zusammen: Vor der
Kulisse des rund 90 Meter hohen Kalkbergs
finden seit 1952 die legendären Karl-May-Spiele
in einem der schönsten Freilichttheater Europas
statt. Dass der Segeberger Kalkberg eigentlich aus
Gips besteht, verzeiht man ihm dabei schnell.
Seine Höhlen haben mehr als 20.000 Fledermäuse
als perfektes Winterquartier für sich entdeckt.

The name Karl May and the city of Bad Segeberg
are inseparable: The Karl May Festival has been
hosted in front of a 90-metre-high limestone moun-
tain backdrop, in one of Europe's most beautiful
amphitheatres, since 1952. It doesn't matter that
the limestone mountain is actually made of
plaster. More than 20,000 bats make the caves
their home during winter.

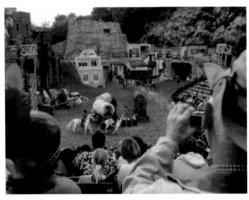

Am Zusammenlauf der Flüsse Beste und Trave gelegen, dominiert in und um BAD OLDESLOE die Farbe Grün. Die größte erholsame Oase inmitten der Stadt ist der Kurpark des einstigen Sol-, Moor- und Schwefelbades mit seinem idyllischen Salzteich und der artenreichen Flora und Fauna. Im Nordwesten der früheren »Salzstadt« befindet sich mit dem Brenner Moor das größte binnenländische Salzmoor Schleswig-Holsteins.

The concourse of the Beste and Trave Rivers, in the BAD OLDESLOE area, is dominated by the colour green. The spa garden in the middle of the city is the biggest relaxation oasis of the former saltwater, mud, and sulphur resort town. It has an idyllic saltwater lake and displays diverse flora and fauna. The Brenner Moor, which is the biggest inland saltwater moor in Schleswig-Holstein, is located northwest of the former »salt city.«

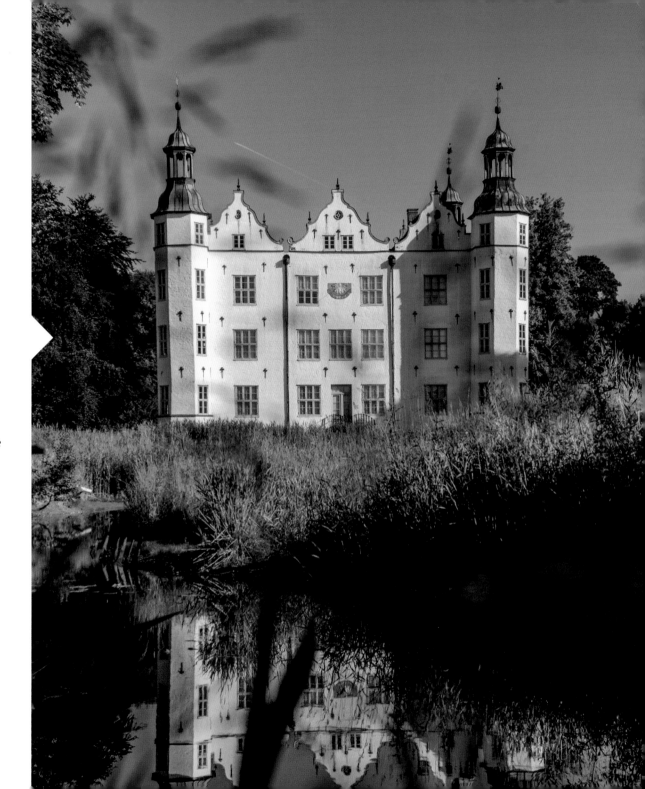

Das strahlend weiße Schloss Ahrensburg, erbaut im Jahr 1585, zählt zu den bedeutendsten Sehenswürdigkeiten des Kreises Stormarn. Seit 1955 als Museum für Besucher geöffnet, präsentiert das Renaissanceschloss mit seinem wertvollen Interieur eindrücklich die schleswig-holsteinische Adelskultur. Die seinerzeit ebenfalls auf dem adligen Gut entstandenen »Gottesbuden« dienen heute noch bedürftigen Menschen als Wohnraum.

The bright white castle of Ahrensburg, built in 1585, is considered one of the most important sights of the Stormann district. Opened as a museum in 1955, the renaissance castle and its precious interior represent Schleswig-Holsteins nobility. The »Gottesbuden,« built on the grounds of the noble estate, still serve as accommodation for people in need.

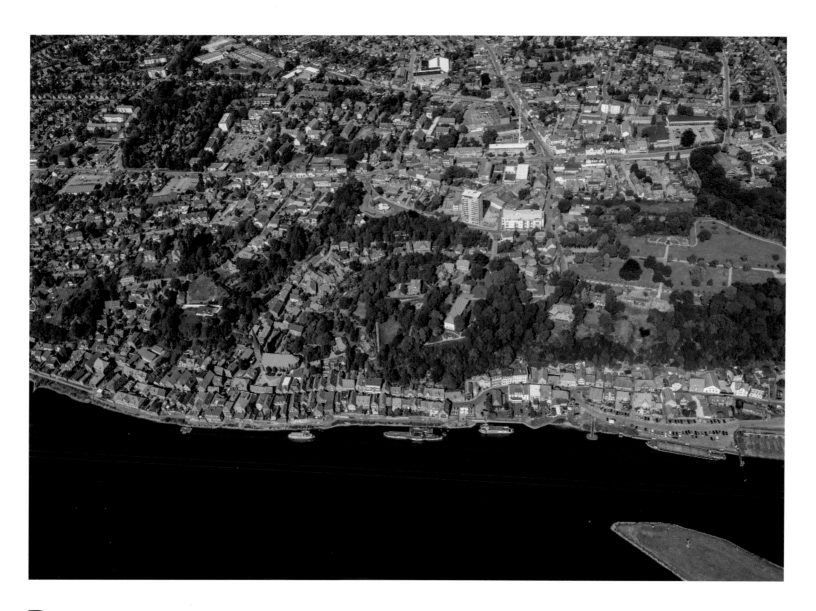

Die verkehrsgünstige Lage an Elbe und »Alter Salzstraße« brachte LAUENBURG im südlichsten Winkel Schleswig-Holsteins ehemals großen Wohlstand ein. Noch heute zeugt die malerische Altstadt mit ihren reizvollen jahrhundertealten Fachwerkhäusern von ihrer Blütezeit. Im Sommer lädt die »Kaiser Wilhelm«, einer der letzten noch fahrenden kohlebefeuerten Schaufelraddampfer der Welt, zu einem besonderen Blick auf die Schifferstadt ein.

Its convenient location near the Elbe River and the »Alte Salzstrasse« (Old Salt Route) advanced LAUENBURG, in the southernmost corner of Schleswig-Holstein, to great fortune. The old town with its centuries-old, beautiful timber-framed houses still tells tales of its heydays. One of the last coal-fired paddle wheel steamers in the world, »Kaiser Wilhelm,« offers an unusual view onto the shipping city during summer months.

Schattige Alleen führen dicht an Feldern und Wiesen vorbei. Zahlreiche Rad- und Wanderwege durchkreuzen auf ruhigen Pfaden die waldreiche Seenlandschaft: Das HERZOGTUM LAUENBURG lockt mit landschaftlicher Vielfalt und herrlichen Naturerlebnissen. Im Süden der Region lässt sich der verträumte Sachsenwald, Schleswig-Holsteins größtes zusammenhängendes Waldgebiet, auf reizvollen Themenrouten erkunden.

Shady avenues lead past meadows and fields. Numerous bicycle paths and hiking trails peacefully crisscross the heavily wooded lake scenery: The DUCHY OF LAUENBURG entices with its large variety of landscapes and natural wonders that promise unforgettable outdoor experiences. In the South of the region lies the dreamy Sachsenwald, Schleswig-Holstein's largest woodland area, waiting to be explored on delightful nature trails.

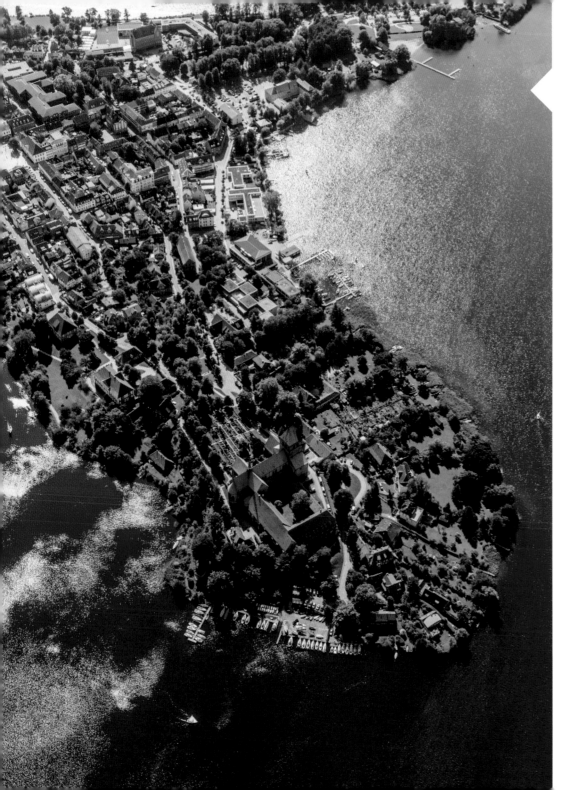

G leich von vier Seen umgeben, liegt die
Altstadt RATZEBURGS auf einer Insel und ist
nur durch Dämme mit dem Festland verbunden.
Gegründet wurde das Bistum im Jahr 1154 von
Heinrich dem Löwen, dem die Stadt auch ihren
imposanten Dom, die erste monumentale Back-
steinkirche Norddeutschlands, verdankt. Seit
1953 trainieren in der ansässigen Ruderakademie
Leistungssportler für ihre herausragenden
internationalen Erfolge.

*The old town of RATZEBURG is located on an
island surrounded by four lakes. The banks
connect the diocese, founded by Henry the Lion
in 1154, with the mainland. The town also owes
its cathedral, the first monumental brick church in
Northern Germany, to Henry the Lion. The local,
internationally successful rowing academy has
been training their squad here since 1953.*

ERHOLSAME AUSZEIT

RELAXING TIME-OUT

Vielen durch die Konfitürenherstellung der Schwartauer Werke bekannt, genießt der Kurort Bad Schwartau bei Erholungsuchenden einen ausgezeichneten Ruf: In Schleswig-Holsteins einzigem Jodsole-Thermalbad wird das natürliche Heilwasser seit 1895 aus einer 348 Meter tiefen Quelle gewonnen und gesundheitsfördernd angewandt. Auf zahlreichen Wander- und Radwegen lässt sich die abwechslungsreiche Landschaft aktiv erkunden.

This city is known for its jams, made at the Schwartauer Werke, but spa town Bad Schwartau also enjoys an excellent reputation among those seeking relaxation. The water for Schleswig-Holstein's only iodine brine thermal bath is collected from a spring at 348 metres below ground, and has been applied as conducive to good health since 1895. Numerous hiking and biking paths offer a great way to actively explore the area.

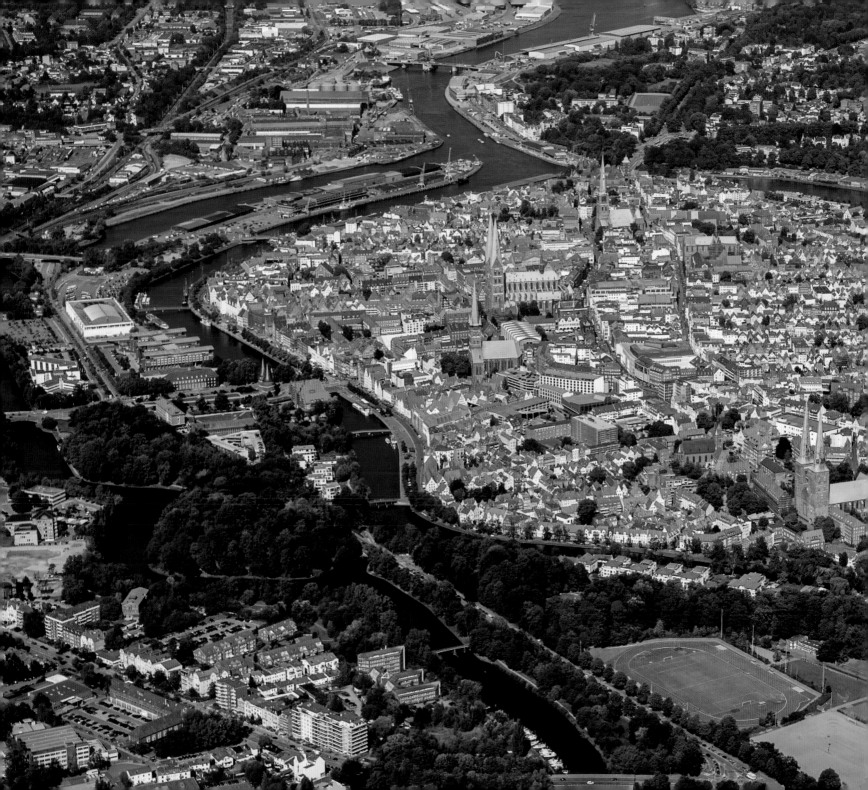

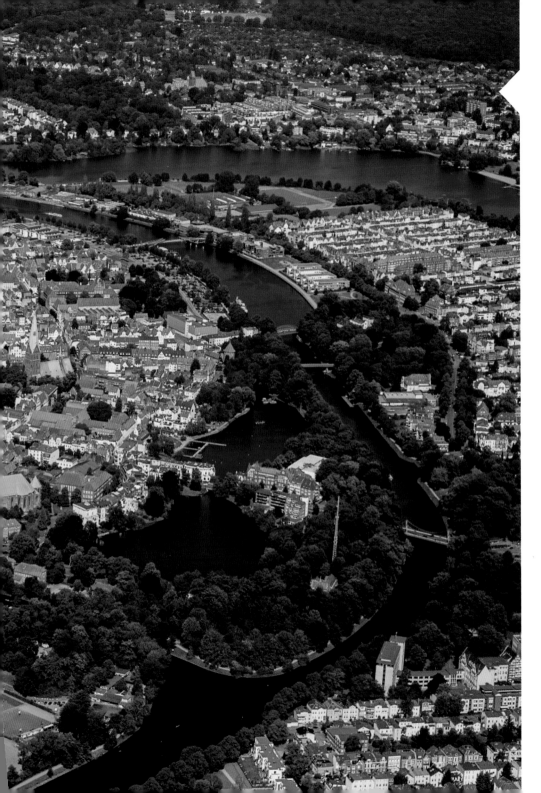

S ie gilt als »Königin der Hanse« und ist zweifelsohne Schleswig-Holsteins schönste Stadt: In LÜBECK, der Kultur- und Literaturhauptstadt des Landes, trifft glanzvolle Vergangenheit auf moderne Szene. Sieben Kirchtürme prägen die unverwechselbare Silhouette der historischen Altstadtinsel, die von Trave und Elbe-Lübeck-Kanal umschlossen ist. Im Jahr 1987 wurde mit Lübeck zum ersten Mal eine deutsche Altstadt von der UNESCO zum Weltkulturerbe ernannt.

The »Queen of the Hanse« is without a doubt the most beautiful city in Schleswig-Holstein: LÜBECK is the cultural and literary capital of the country. The glamorous past meets today's modern scene. Seven church towers shape the unmistakable silhouette of the old town, surrounded by the Trave River and the Elbe-Lübeck canal. In 1987, UNESCO named Lübeck the first German town to become a Global Heritage Site.

Fakten: Lübeck

Hansestadt	seit 1358
Marzipanstadt	seit 1806
Denkmalgeschützte Gebäude	über 1.000
Anzahl Brücken	210
Nobelpreisträger	3

Facts: Lübeck

Hanse City	*since 1358*
Marzipan City	*since 1806*
Buildings under heritage conservation	*ca. 1,000*
Number of bridges	*210*
Nobel prize winners	*3*

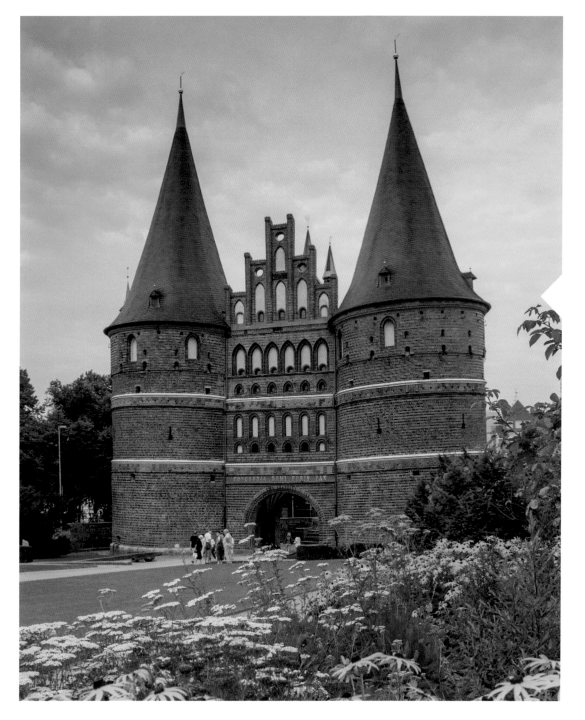

ERBE DER HANSE

HERITAGE OF THE HANSE

Das auffällig nach innen geneigte HOLSTENTOR ist neben dem Brandenburger Tor Deutschlands bekanntestes Stadttor. Zur Verteidigung und gleichzeitig als Symbol der wirtschaftlich bedeutenden Hansestadt wurde es zwischen 1464 und 1478 errichtet. Im Jahr 1863 entging der eindrucksvolle gotische Backsteinbau – aufgrund seines zwischenzeitlich ruinösen Zustands – mit nur einer Stimme Mehrheit in der Bürgerschaft knapp seinem Abriss.

The HOLSTENTOR and its remarkably inward-leaning shape is Germany's most recognisable city gate, apart from the Brandenburger Tor. It was built between 1464 and 1478, as a symbol for the economical importance of the Hanse city and for its defence. The poor condition of the impressive brick building would have led to its demolition in 1863, if it hadn't been for a single vote in the community that saved it from destruction.

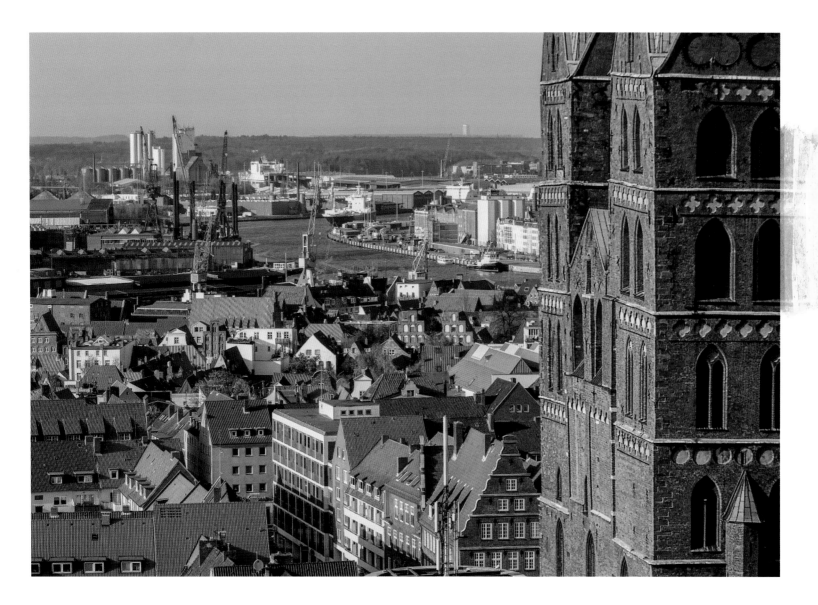

Auf dem höchsten Punkt der Lübecker Altstadtinsel steht erhaben Deutschlands drittgrößte Kirche: die St. Marien. Auch in ihrer baulichen Form hat die schöne Basilika einen besonderen Platz als Vorbild inne: Erstmals wurde hier die französische Kathedralgotik auf heimischen Backstein übertragen. Mit ihrem fast 40 Meter hohen Mittelschiff beherbergt sie das größte Backsteingewölbe der Welt.

From the city's highest point, Germany's third largest church, St. Marien, towers over Lübeck's old town. The beautiful basilica is an architectural prototype because, for the first time, French Gothic cathedral style was copied directly onto a brick building. The middle nave is almost 40 metres high and displays one of the biggest brick arches in the world.

© 2017 Wachholtz Verlag – Murmann Publishers, Kiel/Hamburg
2. Auflage

Fotografien: Oliver Franke, Kiel
Text: Judith Leysner, Kiel
Gestaltung: Strandgut, Kiel
Gesamtherstellung: Wachholtz Verlag, Kiel/Hamburg

ISBN 978-3-529-05346-7

Besuchen Sie uns im Internet: www.wachholtz-verlag.de

OLIVER FRANKE

Zu Land, im Wasser, von oben. Als Fotograf und
Wellenreiter hat Oliver Franke die Welt bereist und
stimmungsvoll festgehalten. Spezialisiert auf die
Bereiche Food und Inszenierung, ist er 2011 mit
seinem Fotostudio in der W8 in Kiel angekommen.

JUDITH LEYSNER

Vom Reisen zum Marketing und auf dem Weg
die Leidenschaft für Bild und Sprache entdeckt:
Judith Leysner, Verfasserin der Texte, ist seit 2005
im Bereich Marketing und Gestaltung selbstständig.
Anfang 2013 hat sie mit ihrer Agentur Strandgut
ein Büro in der W8 in Kiel bezogen.